650

ART AND THE
THEOLOGICAL
IMAGINATION

ART and the THEOLOGICAL IMAGINATION

John W. Dixon, Jr.

A Crossroad Book

THE SEABURY PRESS / NEW YORK

1978 / The Seabury Press
815 Second Avenue / New York, N.Y. 10017

Printed in the United States of America

Library of Congress Cataloging in Publication Data

Dixon, John W
 Art and the theological imagination.

 "A Crossroad book."
 1. Art and religion. 2. Man (Christian theology)
I. Title. N72.R4D48 701 78-16249
ISBN 0-8164-0397-X

as we return to the dust from which we came, the gods die

away into the sky, the womb of gods: from the common
universalized materials we ascend into time and shape, hold our
outlines and integrations a while, then stiffen with the

accumulations of process, our bodies filters that collect
dross from the passages of air and water and food, and begin
to slow, crack, splinter, and burst: the gods from the high wide

potentials of aura, of encompassing nothingness, flash into
concentration and descend, taking on matter and shape, color,
until they walk with us, but divine, having drawn down with them

86

the reservoirs of the skies: in time the restlessness that is in
them, the overinvestment, casts the shells of earth to remain with
earth, and the real force of the gods returns to its heights

where it dwells, its everlasting home: these are the mechanics
by which such matters carry out their awesome transactions:
if the gods have gone away, only the foolish think them gone

for good: only certain temporal guises have been shaken
away from their confinements among us: they will return, quick
appearances in the material, and shine our eyes blind with adoration

and astonish us with fear: the mechanics of this have to do with
the way our minds work, the concrete, the overinvested concrete,
the symbol, the seedless radiance, the giving up into meaninglessness

87

and the return of meaning: but the gods have come and gone
(or we have made them come and go) so long among us that
they have communicated something of the sky to us making us

feel that at the division of the roads our true way, too,
is to the sky where with unborn gods we may know no
further death and need no further visitations: . . .

A. R. Ammons, *Sphere, the Form of a Motion*

CONTENTS

Acknowledgments of Illustrations

1. Temple of Zeus at Olympia, west pediment, Battle of the Centaurs and Lapiths, early 5th century B.C. *Alinari-Art Reference Bureau.*
2. Lapith Youth, detail of fig. 1. *Marburg-Art Reference Bureau.*
3. The Pharaoh Khafre, IV Dynasty, Cairo Museum. *Marburg-Art Reference Bureau.*
4. Sounion Kouros, ca. 600 B.C. Acropolis Museum, Athens. *Marburg-Art Reference Bureau.*
5. Athens, Acropolis, distant view. *Alinari-Art Reference Bureau.*
6. Wooing of Galatea, Villa of Boscotrecase, 1st century B.C.
7. Rembrandt, *Bathsheba,* 1654. Paris, Louvre. *Marburg-Art Reference Bureau.*
8. Ara Pacis of Augustus, processional relief, 13–9 B.C. *Anderson Art Reference Bureau.*
9. Portrait head from Delos, ca. 80 B.C. National Museum, Athens. *Marburg-Art Reference Bureau.*
10. Altar of Zeus, Pergamum, ca. 180 B.C. Berlin Museum. *Bruckmann-Art Reference Bureau.*
11. Orange, Catacomb of Domitilla, Rome, 3rd century A.D. *Alinari-Art Reference Bureau.*
12. Santa Sabina, Rome, interior, A.D. 405. *Alinari-Art Reference Bureau.*
13. Arch of Constantine, Rome, reliefs, A.D. 117–38 and 4th century. *Alinari-Art Reference Bureau.*
14. Book of Kells, Chi-Rho page, 8th century(?), Trinity College, Dublin. *Green Studio-Dublin.*
15. Pantheon, Rome, A.D. 118–25 (later engraving). *Anderson-Art Reference Bureau.*
16. St. Sernin, Toulouse, apse, 1080–1120. *Marburg-Art Reference Bureau.*
17. St. Trophime, Arles, facade, late 12th century. *Marburg-Art Reference Bureau.*
18. Giovanni Pisano, *Isaiah*(?), Siena Cathedral, 1284–99.
19. Donatello, *St. Mark,* Or San Michele, Florence, 1411–13. *Alinari-Art Reference Bureau.*
20. Beauvais Cathedral, interior, 1247. *Marburg-Art Reference Bureau.*

21. Amiens Cathedral, Apostles from Central Doorway, west front, ca. 1220–30. *Marburg-Art Reference Bureau.*
22. Giotto, *Presentation in the Temple*, Arena Chapel, Padua, 1305–6(?). *Alinari-Art Reference Bureau.*
23. Giotto, *Noli Mi Tangere*, Arena Chapel, Padua, 1305–6(?). *Alinari-Art Reference Bureau.*
24. Donatello, *Feast of Herod*, Baptistry, Siena, ca. 1425. *Alinari-Art Reference Bureau.*
25. Rembrandt, *Syndics of the Cloth Guild*, 1661–62. *Amsterdam, Rijksmuseum. Bruckmann-Art Reference Bureau.*
26. Couture, *Romans of the Decadence*, 1847. Paris, Louvre. *Alinari-Art Reference Bureau.*
27. Balthasar Neumann, Church of the Fourteen Saints ("Vierzehnheiligen"), 1742–72. *Marburg-Art Reference Bureau.*
28. Nicholas Hawksmoor, St. Mary Woolnoth, London, 1716–27. *A.F. Kersting-London.*
29. Paul Cézanne, *Mont Sainte-Victoire*, 1885–87. *The Metropolitan Museum of Art.* Bequest of Mrs. H. O. Havemeyer, 1929, *The H.O. Havemeyer Collection.*
30. Frank Lloyd Wright, Kaufmann House ("Falling Water"), 1936–39. *Bill Hedrich, Hedrich-Blessing, Chicago.*
31. Paul Klee, *Twittering Machine*, 1922. Collection, *The Museum of Modern Art, New York.*
32. Paul Klee, *Ad marginem*, 1930 and 1935–36. *Kunstmuseum Basel.*

PREFACE

This book is substantially the Hale Lectures as delivered at Seabury-Western Seminary, November 10–12, 1976. There is always a problem connected with the transfer of lectures to the printed page. My own conviction is that the more personal, more informal tone appropriate to the lecture format is appropriate also to the subject. These are not matters of objective scholarship to be reported in coldly objective language. They are matters of interpretation, of commitment. The use of personal pronouns, the identification of statements as opinions, the raising of unanswered questions, should emphasize that this argument is a part of a conversation. I have, therefore, chosen to preserve the original style of the lectures, as itself a part of the argument.

For purposes of publication, the text has been expanded. Chapter One treats of theoretical matters that were cut when the original lectures were reduced from four to three. For the rest, the expansion has taken the form primarily of enlarging the lectures as given to provide other examples and somewhat more detailed treatment of the issues. Consequently, the chapter divisions no longer correspond to the original lectures. Chapters Two and Three contain much of the substance of a paper also presented to the Center for Hermeneutical Studies in Berkeley, California and published as #24 in their Protocol Series. I am grateful to the

Center and its director Wulhelm Wuellner for permission to re-use this material and for their hospitality when it was presented.

Anyone who wishes to skip the theoretical abstraction of Chapter One and begin directly with consideration of the works of art has my fullest encouragement. The theory, does, however, provide the point of departure for the rest of the presentation and I hope such readers will come back to it.

I should like to express my deep appreciation to the Committee for the Hale Lectures and the Trustees of the Fund for their generous invitation to give these lectures. I should like also to thank the audiences for the lectures, who were courteously attentive, generous in their response and searching in their reaction. I should like further to thank all those whose generous hospitality made the lectures less of a formal and detached presentation, more of a part of the continuing life of the community.

While the hospitality was so general as to make special attention to particular persons invidious, I do want to thank particularly Professor Paul Elmen, chairman of the Committee on the Hale Lectures, for managing the visit with ease, efficiency, and charm; and Professor W. Taylor Stevenson, whose constant encouragement of my work over the years has been both support and sustenance.

one

FORM
AND FAITH

The most serious question facing theology now is whether or not it has a right to exist.

That right has been taken for granted for a long time. Not only has the right of theology to exist been taken for granted, the right of theology to exercise authority in religions has been equally accepted; the whole principle of heresy and persecutions is built on the assumption that a verbal statement so exactly sets forth the sacred that denial of the statement is an offense against the Holy One himself.

The grant of authority has largely been withdrawn. A few groups still huddle closely around a creed but, for most, creeds have no standing. The loss has been a trauma for a great many people; for some theologians the trauma has been so great that it has been easier for them to assert that God (as subdued to theology) has disappeared than to accept the fact that theology has nothing like the scope or the power it once so securely seemed to have.

The way out of the dilemma is not to abandon theology nor to try to reassert its ancient authority but to accept the possibility that the question has been wrongly stated. The true problem may be, not the existence of theology nor even its authority, but its *nature*. What does theology do that can-

not be done better another way? What language is the appropriate one for theology?

Given the history of theology, the history of the western mind, the last question is the startling one. Words have been thought to be, not simply the most appropriate language for theology, but the only language in which theology is possible.

This is a strange claim. Fortunately for those who do not believe it, it can be checked. It can be checked in both directions, toward the object of its deliberation and toward those it presumes to exercise authority for.

The second of these checks is the proper concern of this study but it is not altogether separable from the first. The claim to talk seriously and adequately about the omnipotent God is itself sufficiently startling, for to reduce God (or for that matter, anything) to the content of a proposition is to replace omnipotence with a new authority since the content of a proposition is subject to the authority that produced the proposition in the first place. A god described is a god subdued in servitude to the act of description.

Furthermore, all propositions have the inevitable effect of reducing the variety of human experience to a single theme. The clearest illustration of this is the fate of the Protestant Reformation. The generating principle of the Reformation was justification by faith. Within a few years of the beginning of the Reformation the decisive principle was not justification by faith but believing in the doctrine of the justification by faith, which is obviously not faith but a work. All theology is a work of human reason and, by asserting authority over the whole of faith, reduces faith and all devotion to a work of reason.

For the second check it becomes necessary to ask a further question: how much of our life is lived in words or according to words?

It is not a simple question. We live much of our life "in"

words, in the acts of talking, of saying, of asking, stating, pleading, arguing, loving, all the multitude of things which the delicate and powerful flexibility of our language permits. We live "in" our language to the extent that the shape and order of our language shapes the very perceptions we have of our world. Much of what we see we do not see in itself but in the patterns fixed in our perceptual apparatus by the forms and rhythms of our language.

We live "according to" our language; we experience the world according to the picture we have of it built up in our words. Poetry is not an entertainment; it provides us with the shapes of our emotional life. Belief can be so powerful that it overrides clear and present evidence.

Thus the idolatry of words is not simple delusion nor is there need or good in thinking of displacing words from a position of centrality in our life and thought.

The question remains: how much of our life do we live in words and according to words? If the form of the question suggests any disrespect for words, then it can be put the other way around more positively: how much of our life do we live outside words, according to forces other than words?

The answer is simply—all of it; all our life, all our corporate lives are lived outside words. Words insert themselves into the vast reverberating web of our common life, disturbing and shaping the interacting relations of our somatic life. In turn, words are seized by the forces of our life and shaped to the expression required of them. Words are an indispensable instrument of being human as they undoubtedly serve to our becoming human. But our life is not in words.

I do not speak of "life" in any cosmic or metaphysical sense; that sense is derivative. I speak of life as we experience it in the course of an ordinary day. As we wake in the morning we can feel our senses gathering into cohesion out of the blankness, shedding the weird mystery of the sensory disorder and symbolic power of our dreams. With conscious-

ness, there comes the awareness of the texture of bedding, the crumpled pillow as evidence of physical acts we don't remember, the muscles stiff from unchanged positions, the body heavy into the mattress. Vision comes into focus, and awareness of the morning light, sun across the bedroom floor, or the grey sky outside with the blackness of tree branches silhouetted against it. There follow then the first acts of the body's day, the awareness of the pain of a distended bladder, then the unwelcomed movement of the body from the bed, the voiding of a liquid through a channel, the sound of water running against the sounds of the day outside.

This account of a few moments of a typical day is itself too short and insensitive to do more than suggest the infinite complexity of experience which is the life of our flesh. Even those few moments are an undecipherable and indescribable web of interaction between sensation, memory, emotion, purpose.

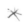 Our life itself is lived physically in an intensely physical world. We do not live in a world of words but a world of sound and color, weight and textures, lines and surfaces, masses and volumes. The intricate network of our bones and muscles moves us through the volumes of our rooms. We fumble in the intimacy of closets and chests for the garments of our privacy and the costumes of our public selves. We handle objects of all sizes and kinds and shapes. We move from the condensed and familiar spaces of our houses into the openness of the spaces of our day, into sounds and movements of a different kind.

It is quite beyond description. Yet it is the life we live—or a tiny sample of it. I have not mentioned those other bodies like our own that make up so great a part of our experiences, those bodies variously attractive or repulsive or simply a condition of the world we live in. But these too are all or part of our world.

In describing our world this way, I have not only drama-
tized the assertion that human life is basically tangible, physi-
cal, solid, present. I have by implication established our life
as the same as lives we think of as simpler and thus other
than our own. My life in the morning involves the steel and
plastic of a razor, the container of shaving cream, an electric
stove and a television set. I have seen poor Indians waking
from a rope bed on the sidewalk, the only bed clothes the
garments they wear. But they move with the same slow, un-
welcome stiffness, stretch, rub their eyes, wander off toward
some private corner. The dog wakes from his curled up
state, shakes himself, stretches, yawns, casually urinates
against a tree. The Indian, the dog and I are at different
levels of complication but we are in no essential way dif-
ferent in the involvement of ourselves and our world. We
are all organisms, born into the inchoateness of early life,
growing and acting, dying, decaying back into the soil. The
dog and the Indian and I come from the earth and will go
back into it.

The Indian and I differ a little from the dog in that the
dog accepts who he is absolutely and never does anything
about it. His role in the order of things is set for him. He
does not think about it or criticize it or change it. In all the
simplicity of his being he manifests it. He simply is, without
thought or complication.

My Indian friend on the sidewalk is not able to do much
more. He is a poor man, a victim, subject to forces he cannot
control, one of those nameless ones who become data in the
reporting of disaster. Yet he would if he could be other than
he is, if only to have a better bed and another meal. He can
dream and desire and act a little. He has few ideas because
he cannot read and has never been taught but his ideas are
human ideas. He can do human things.

It is I, or people like myself, who commit the greater pre-
sumption. We forget who we are. We forget that the lunch

we ate indifferently while we argued metaphysics or policy is now being dissolved and transformed into flesh, bone, blood and feces. We void our waste in a straining indignity of posture, never believing other than that we are lords of the universe.

Not myself, perhaps, for few of us really believe we command our destiny. It is rather Man, that ideal abstraction of our purpose, who claims to exercise authority over things.

Somewhere in our past we convinced ourselves that this burgeoning life of our flesh was merely an instrument for the purposes of whatever it is that enables us to be aware of our flesh as the dog is not aware. Our flesh brings the self the information it needs but the self itself, now identified with "mind," can know the meaning and use of this information, can determine a purpose and, by the exercise of will, use knowledge to attain that purpose.

Being human became defined as mind, which was identified with knowledge and will. The awareness of the flesh, the acts and the being of the flesh in the earth, fell away, became part of the other. The flesh, the body, as the other, could be seen, observed, described, explained, by the knowing will. The mind, understanding all, could legislate for the body, decide for the body what the body is, what the body should do. The body is considered an exasperating nuisance. Its weakness obstructs the truly human work of the mind since the most intense discipline has not wholly freed us from this painful dependence on the flesh. Hunger distracts us, sleepiness blurs our thoughts, the thigh of a pretty girl can throw the whole process out of key. Hunger and sleep and the thighs of girls ought to be, are intended to be, subject to the knowing will.

The story of Phyllis astride Aristotle is childish history. But it is better psychology than Platonic or Cartesian rationalism.

The definition of man as a knowing will accomplished

much and taught us much. Yet slowly its consequences began to close in on us. Controlled and exploited nature turns on us as though it were a willful person. We conquer the arid lands to feed ourselves and the desert creeps over all our works. The poisoned air sickens and kills us. The earth itself begins to rebel.

Worst of all, we are cut off from our being. I am a man, not Man, and the works of Man are something outside myself, other than me. I live according to the dictates of the knowing will and, taught that Man knows the truth, I find that other men have a truth that is quite different from mine. Then I see that the world I live in is quite incommensurate with the Truth I was taught. Things don't do what I was taught they do. The knowing will understands the situation and acts on it causally, producing not the intended effect but something quite unexpected, often undesired, usually undesirable.

Is it possible that our definition was wrong, that we are really men and women and children, not Man? That there is more to life than knowledge, more to the human than mind? If it is not so we are lost in our own world.

Perhaps if we can redefine who and what we are we can find a more secure place for the arts. In a world dominated by the knowing will there isn't much of a place since the important instrument of thought is the verbal formulation of whatever the willful knowing has determined.

But to redefine ourselves as human it is necessary to build on the fact that we are, at the same time, animals. If we move back from the presumptions of the knowing will and seek our definition in our common life on the earth, there is no way we can stop short of the truly common life, the life we hold in common with all living creatures. There is no way, in fact, to stop short of our physics and our chemistry as well as our biology; if we are truly involved in the earth then we must be *truly* involved and that means taking how

we are made with complete seriousness. If we are made of the matter of the earth, incorrigibly involved in life's vitalities, then our lives are truly lived in the structures and energies of the earth—not simply dramatically, but physically. And we know now that physical life is not made of things but of energy in tension and that reality is not an accumulation of objects but a vast interlocking web of structured energies.

All things are structures of energies in tension, everything that happens is the intercourse of elementary particles in ordered and energetic relation. Once this would be called reductionism; it is not.

Indeed, everything that is and happens is "nothing but" the interaction of elementary particles but it is precisely the marvel that elementary particles do what we now know they do. We are not demeaned but ennobled by being reduced to the substance and quality of the earth.

In this study we come late to the process, inserting our attention at the point where the structured energies have already become an enormously intricate hierarchy of interacting and interdependent systems. We take up the story at the point of transition between the animal and the human.

There isn't much that truly separates us from our brothers the animals, but that little is decisive. Some animals can do everything external that we consider uniquely human. So far as we can tell no animal thinks about what he is or is aware of his own uniqueness. Animals have consciousness but not *self*-consciousness so they are content to be what they are and simply exist without any change.

At the point of becoming human, as the means of becoming human, one animal became aware of itself. Awareness of the self had great and grave consequences for the self, not least of which is its defining characteristic. If I am aware of my self, I can know myself only as something other than everything else; awareness of the self is not possible except in

corresponding awareness of the other. Awareness of the other correspondingly transforms the self.

Where the self is is here; where the not-self, the other, is is there. Thus, from the very beginning, self-consciousness (which is humanness) establishes an ordered space, which is symbolic space; awareness of the other, in its simplicity, establishes a relation.

We cannot know the animal's experience of space. It is intricate and emotional. So much we can tell from their behavior. There is no reason to think it is symbolic space. It is the space for the enactment of the lovely routine of their lives.

So is our space; it is the space of our drama and our emotional life. But for us it is more. The other is there, across a distance of space and the other is all there is. Or all there is is other. Self-consciousness remorsefully brings with it the fatal questions: How am I related to the other? How ought I to be related to the other?

Thus, description and imperative impose both drama and morality. The relation with the other is not determined by the genetic pattern but is shaped, rather, by desire, commitment, obligation, fear.

The knowing will assumes that the relation can be both understood and ordered by the reasoning intelligence outside everything but itself. Much of a great modern philosophical movement (existentialism) sees the act as isolated in a void. But the dramatic is one coordinate of two, the other being the spatial. The ought must be enacted in a space and the space imposes its shape on the relation.

There is a third coordinate: purpose. I have postulated a paradox as the substance of the human. We are animals, we are organic substances, participating in the vast reverberating web of relations that is the life of nature. As humans, we are aware of our place in the natural order and awareness makes us other than what we are. By nature we are a part of nature. By nature we are apart from nature.

It is the fatality of the human. We are caught in an insoluble paradox. We only yearn for a solution which can, in an abstract scheme, fall under a few different types. Most common, perhaps, is the yearning to return to the indissoluble unity. Our flesh feels it by its involvement in the orders of the earth, by our observation of the polyphonic unity of our world. Or we can affirm the separation and accept the otherness of all that is not ourselves. This generates a sense of enmity (the other is false, an evil to be fought) or another sense of unity (the other is a subject to be subdued). Or we can accept the infinite otherness of all that is other.

Thus the categories of otherness—space and drama—are not simply the categories of the arts. They are the forming categories of theology. In the above I have suggested schematically the origin and shape of the major religious attitudes: monotheism, dualism, the various modes of polytheism.

It is only schematic; the particularities of religion are too intricate for any scheme. But the scheme provides the nodal points of any analysis and places the arts where they belong.

The space between the self and the other is not only an abstract space. It has all the immediacy and concreteness of a place. Thus the abstract relation is always embodied in the shape of place.

One of the delusions of the knowing will is the feeling that all men since the beginning have been equipped as we are, with an informed understanding which, for various quirky reasons of their own, they have used differently. This is not simply a delusion; it is an arrogant superstition. These early creatures had to build humanness from the ground up.

Almost literally from the ground for they were of the earth, earthy. It was, for them, the dawn of creation when they were first made aware that they *were*. They knew nothing that animals do not except they knew, as animals cannot,

the self and the other and the great desire that grows out of the sense of otherness.

And so the symbolic order, which is to say the human world, began to appear. From the first, it must have been an undecipherably intricate order, for space and drama and purpose appear in every guise and interact in extraordinary complexity. The space of place is not isolated but is traversed by the body in its particularity. Other persons are not dramatic objects only but are bodies to be known in mass and volume; the dramas of relation are worked out in the clash of enmity or the entry and friction of love.

Objects are themselves and also concentrations of meaning. Acts and objects and place are inseparable. Purpose creates meaning in objects as objects lend both shape and personality to purpose. Accident determines a relation which then shapes an act that alters the tonality of space. A symbolic order creates possibility which creativity uses to generate an altered symbolic order.

In other words, human life is too intricate, too varied and complex, to be dealt with by any formula, far too complex to receive its definitive statement in any one language. What I have described is the life of forms, of human life in forms.

The elements of form can be grasped, even if the complexity of relation cannot be. The elements are not even obscure or mysterious for they are, allowing for differences of place, the elements of our ordinary life. Our life is lived in space with objects and persons. Ordinarily we simply use each of these for some fancied meaning or purpose, abstracting from them the pertinent idea. But if we simply *look* at them, look at the world we actually live in, or more than look, become aware of the whole sensory order of our world, we find all the elements of art—shape, mass, texture, color, sound, rhythm, line, edge, weight, movement and all the many elements of our sensory world.

We know, too, in our own experience the thematic elements. We have our own deeply felt need for a center. There are the sacred places of our own lives which in their way are centers. There is the deeply felt need for a center which means that a quite ordinary place is transformed into a center when a quite ordinary citizen of it achieves a position of power. The archetypal figures are primal themes— the wise old woman, the king, the bloody child and all the many others.

There are, as well, the symbolic objects that are archetypal themes: darkness, storm, music, blood, the sea, the phallus, the breast, etc.

A complete catalogue of these separate elements is, at least, conceivable. What is not conceivable is any catalogue of the forms in which they variously appear. One modulates into another or combines with another to create something new. They interchange and interlock. This is metaphor, the linking of apparently different things by some profoundly felt connection between them. At this point metaphor is the basic act of thought.

Thus the making of the work of art is basically a metaphoric activity, the penetration into the secret life of things to find the bonds between them. These, then, contain the inchoate expressive and affective life. Thus the elemental forms and the elemental themes engender a unique form that is critical in shaping the human world. Art is not an ornament to an existing world, it is the primary means of forming that world.

Primary in time, perhaps, for "art" is not always quite so basic to the imagination. It might be said that it is truly primary only when there is no such thing as "art." "Art" is a modern or at least a culturally late name for an activity that can receive a name only when it has come to be thought of as a separate activity that can be set apart, looked at and

named. When it is functioning at its most elemental level it is named only as breathing might be named: to designate an essential activity, not to point to a thing set apart.

On the other hand, form or forming is always primary. It is one of the delusions of us word mongers, as we have learned the changing role of art, that our work has now usurped the role once played by art. Perhaps by "art" but not by forming which is the essential role of art. "Art" in our day is an entertainment of the wealthy bourgeoisie and so forming is left to instinctive and often mendacious forces. But forming has lost none of its ancient power.

There was an interval when the forms of argumentative theology could indeed carry the weight of human meaning but as the argument or the statement began to be isolated from the form it got further from the reality of human life. Argument began to emerge from other argument by logical construction rather than from human life by form. There was no reason for most people to concern themselves with the intricate and inward dance of the theological argument; it had nothing really to do with them and once they got rid of the oppressive and destructive power that claimed its authority from argument there was no more need to attend to the conclusion of argument.

Many people are distressed and concerned about this problem. They think they ought to be concerned about the argument and believe its conclusion. Their expressed opinions ("I believe") are an accumulation of fragments picked from the rag bag of old arguments. But what they are has been formed elsewhere. For forming is the essential act of the human.

What is to be done?

Nostalgia won't do. We cannot go back to Lascaux or Chartres. Old forms deal with us differently. If we can grasp their forming we can learn through them something of the

nature of forming. If we grasp their forms we learn some of the possibilities of being human. But we are the only ones who can control our own forming.

So the immediate task is to find out something of what forming is like. For the present purpose it is necessary to concentrate on forming as theology, the forming of the gods. Forming is many things and penetrates into all aspects of the human. Equally it draws all aspects of the human into the forming of the gods. Therefore, any great work of art requires a book at least for the beginning of its telling.

Even so there is something to be gained by briefer examination, focused on a selection of the forms, for that provides a clearer sense of the interdependence of forms and their change in time, which is history.

It is the art people, not the word people, who have obscured something vital about art by overstressing the sense of its connectedness in time. Art history is not art but what art historians do with art. Art works do not emerge as a logical result of a historical development, which is what the history of art presupposes. They emerge out of the acts of certain people within the particularities of a situation.

But art history is not quite a vanity and a striving after wind any more than theology is. Both represent important human acts.

I am proposing that there is a development in the history I shall sketch out but a development that needs to be distinguished clearly from the usual types of development.

"Development" usually suggests the fulfillment of an inevitable historical process or a progressive movement toward a superior form. The evidence is so strong against both that it hardly seems necessary to argue the case, even if this were to be the place.

There is, indeed, intelligible and connected change in the history of art as there is in the history of culture, but it has nothing to do with the working out of determined law or the

fulfillment of a preordained shape or the attainment of some ideal goal. It has everything to do with the fact that people learn from other people and tend to work in the manner they are taught. They grow up in the same climate, live in the same human and natural landscape and thus tend to think in the same forms. The forms change because those who are taught have learned something they do not have to spend a lifetime acquiring. They are free, therefore, to use such creativity as they have to move further along.

Since the successive achievements are not fixed into the predetermined and inevitable shapes of history, they remain available as resources for human development. We cannot truly return to them in any way faithful to what they did but we can use their basic insights.

Thus there is a development of sorts but only if we chose to make it so. We can choose to learn and to use what our predecessors have done and in doing so we learn more about the possibilities of being human. Artistic styles are not simply convenient diversions for the work of the art historians. They are explorations of modes of being human.

There is no question now of "true" or "false"; they are here, to be known, because they are possibilities of ourselves. A style is an essay in human psychology. A style is a manifestation of one of the possibilities within the matter of the earth.

All styles are thus revelatory of our humanity. It is no longer necessary or humanly right to take styles as badges of party; the matter is too serious for that. The style that belongs to "our side" is not inherently better than another nor is it at our disposal to say that our style sets out the one true God for the God that could be set out in a human style is no God. The styles are human achievements; the great gods are nodal points of the great styles. They are the concentration of human energy as shaped by the totality of the style. They are, they live, in the wholeness of the style. The

gods are ways of understanding human life in the conditions of the earth. It is useless polemic to denounce "false gods." All gods are false because all gods proceed from human finiteness and weakness. All gods are true because they manifest something in the wholeness of experience.

All the gods have been and can still be idols. *All* the gods can be idols. All the gods can also be means of grace, for they are embodiments of the order and energy of being human, the setting forth of a human mode. They are not to be worshipped but understood, yet understood with the deep sympathy that makes it understandable that they should have been worshipped.

There is a program of study here. Its fulfillment would be a history of the human enterprise. Who could write such a work? I do not know. I propose here a more modest study which will focus on one continuous cultural tradition, the one that began in Greece and Palestine in the first millennium B.C. I do not propose anything so grand as a history of that great epoch but a selective examination of a few moments in it.

Every moment, every manner of style, reveals some crucial aspect of the people who made it. Furthermore every moment is a change from what went before to what came after. Yet there are critical moments in history and in the development of style, moments of great change when life before and life after are markedly different. Between these moments the changes are still within an orderly progression of relation. These moments, these changes, are epoch making; one epoch closes and another begins. I have selected six of these:

1. The movement from the ancient world to the world of classical Greece, one of the two sources of the west.
2. The movement from the classical world to what is called the "late antique" if the evidence is drawn from pagan culture or "early Christian."

3. The movement from the early Christian to the misnamed "medieval" period. This is the moment when Germanic and Celtic energies entered Christian culture, the latter itself a fusion of Hellenism and Hebraism. This should, perhaps, be called "early western" since it is something truly new and not a "middle" age, but overemphasis on the newness obscures what is contained in the term "middle"—that this culture more than others did succeed in using the work of another culture.
4. The movement from "early western" to the equally misnamed "Renaissance." Again, the name emphasizes a profound and unique use of the insights of the past, a paradigm of creative incorporation of the work of other men into one's own (as well as a paradigm of deadly and sterile imitation).
5. The movement from the "Renaissance" to the "modern," a term of use only in designating the world we live in.
6. The movement from the modern into—whatever is to follow. This is not an attempt at prophecy. I have no greater insight into the future than anyone else has nor do I believe it is so fixed in shape or determined in direction that anyone can prolong the lines of present energy into an imagined future and read off the course of events. I do believe there are resources in modern art, barely recognized and little used, that can guide the choices that have to be made.

This is an outline of history and I have in my title committed myself to a study in theology. The case should rest more on demonstration than on argument. But history is theology, the setting out in act and object of the human vision of the holy.

Whether any or all or some of these visions are sacramental to the Holy One is not for me to judge. I suspect none are in themselves but that all in their several ways are both

the means and the judge. If we receive them into ourselves and, in receiving them, receive those who found them to be the incarnation of their human meaning, we might find all a chalice for the carrying of grace.

two

THE BIRTH OF NARRATIVE
AND THE
FORMING OF THE SOUL

An author is responsible for making clear to his reader the definition of the terminology of his title. I expect to face that responsibility directly with the word "narrative." I shall propose a rather special meaning for the word but a meaning that has no inherent difficulties.

"Soul" is another matter. It is a term in theology and devotion, not in art criticism, and devotional terms do not lend themselves to ready definition. They are intended to evoke feelings, channel certain energies, shape attitudes. They are not intended to function neutrally in an intellectual argument.

I should like to rescue the word "soul" from its devotional use even while I hope to return it refreshed and refurbished for use in a different devotion. So far as it is accessible to definition at all, "soul" usually means some variant of the ghost in the machine. The soul is in the body but not of it. It is something, some thing, that can leave the body at death and go to other regions which are themselves considered as places. It concerns me very much that such a definition is not supportable intellectually or scientifically. It concerns me

even more that it leads to false devotion and false theology.

Precisely because it is more of a devotional term than an intellectual, theological one, I shall not begin with a definition of it in the expected fashion but rather attempt to evoke a sense of it in its historical working. This is not an attempt to evade responsibility but is, I trust, more faithful to the soul itself, which is not a thing but a dimension of the human, or a modality of being human or an achievement that creates the truly human. The more arduous and more misleading task of formal definition I shall defer.

In defining my intentions this way, I have left the way open to another serious misunderstanding. I shall deal with several episodes in the development of western culture, thereby clearly implying that the forming of the soul is an achievement and a responsibility of western culture. This is not true and it is no part of my intention to suggest that it is. Choices have to be made. I have made what I hope is a reasonable choice; the treatment of the soul in other cultures will have to wait for other occasions.

The choice I made was first unconscious and only belatedly recognized. I began with the intent to make a series of presentations, and only later realized that each of my chosen moments was distinctively a moment of transition. The soul in its nakedness is most visible in times of cataclysmic change and, since we are in such a time ourselves, we might better know our own responsibility if we knew more of how other people conducted themselves in comparable times.

We have inherited the results of a long history in which the primary language for ordering ourselves in our world has been one of verbal propositions in the form of theology, then philosophy and finally science, which proceeded to carry the process to its inevitable conclusion by passing beyond propositions into formulas. With its primary task thus usurped, philosophy (and its theological form) turned

to a kind of incestuous concern with its own tools and transformed itself into an examination of language.

Such an enterprise is hardly likely to be nourishing to those who once fed themselves, however poorly, on the crumbs that fell from the philosophical-theological table, nor is the enterprise likely to lead to the production of anything that would be newly nourishing.

A restless concern has led many to try another approach, several other approaches actually but one in particular that concerns me now—a concern for story, narrative, the unfolding of experience in time.

In a splendid paper, "The Narrative Quality of Experience," Stephen Crites summed up much that is best in this concern for story by asserting ". . . the formal quality of experience through time is inherently narrative."[1] The way to this statement has been prepared by many leading modern thinkers. It shifts thought away from the issues that had been of central concern and thereby suggests a major shift in the intellectual methods whereby we investigate our experience.

However much I am indebted to this line of thought, however much I welcome this kind of transformation in thought, I am compelled to say that, in its unadorned state, its unqualified state, the statement is false. I would prefer to be able to say it is partial or inadequate, but the problem with partial statements is that, when they are thought of as a whole and not partial, they can do the same kind of damage false statements can do.

To resolve the partial statement partially it is necessary to balance it with another: "The formal quality of experience through time is inherently spatial." But it is necessary to be more faithful to the modern intelligence than that for, after Einstein, it is not possible to treat space and time separately; it is not possible to talk with any final seriousness of one

dimension without the other. So, I will assert: the formal
quality of experience is spatial and temporal; the structures
of experiences are enacted in space-time; the narrative that
is the formal quality of experience may be grasped only
within the coordinates of space and time.

It is not mysterious that this should be so although, by
cutting the work of the intelligence off from the arts, we
have made it a mystery. Our narrative is enacted in space-
time. Space and time are parts of the narrative; we are not
simply placed in neutral space and neutral time. Most of our
thinking has succeeded in escaping that inescapable fact by
pretending that we are independent knowing wills that hap-
pen to occupy an unavoidable spatio-temporal structure. But
inescapable facts have a way of resuming their inescapability
and we live now with the consequences of a knowing will
that we thought could live as an observer outside space-time.
Space and time are dimensions of ourselves and not simply
limiting conditions of an independent self. If we are to take
symbolic structures as seriously as we ought we must realize
that space and time are constituents of ourselves in a much
deeper way than they are for our brothers the animals who
seem to be far more limited than we.

For them, space and time are simply the outer limits of a
life that is essentially the fulfillment of a natural process with
no symbolic involvement at all. Our involvement with space-
time is engendered precisely by our awareness of it; a con-
sciousness of the self carries with it the consciousness of that
which is not the self; a consciousness of the not-self carries
with it a psychic tension that is the source of our primary
symbolic structure. The not-self is there and not here, where
the self is. The not-self, as other than the self, is there to be
dealt with, so the self and the not-self must be in a relation.
Since the not-self is itself divided into things that behave as
though they also are selves and things that do not, the rela-
tion becomes complex. The ordering of the spatial relation is

deeply influenced by the dramatic relation: how I am related to the other, how I ought to be related to the other, each requires a specific relation in space which, by subsequently assuming symbolic force, significantly affects both what is and what is thought about the ought. Thus the texture and form of experience is, inseparably, a matter of space and time, of space unfolding in time, of time rooted in space.

By blurring two words, by postponing their definitions, I have avoided an issue that I no longer wish to avoid. That is the differing definitions of the words "narrative" and "story."

I shall propose and use my own definitions. I shall reserve the word "story" for those things ordinarily thought of when either word is used—the recital of events as they develop in time. "Narrative" I shall apply to the deeper structures of our experience which emerge into story but also emerge into other aspects of experience as well. Thus the formal quality of experience through time *is* inherently narrative, but story is not the only way to get at narrative.

I entitled an earlier version of this chapter "Art as a Hermeneutic of Narrative." We are all instruments of biographical accident; my title originated in a casual comment to a colleague to the effect that I ought at some time to do something on "art as a hermeneutic of narrative." His reply was to ask "How can a non-temporal art interpret a temporal art?" Thus challenged, I took up the gage for in my tribe of men that distinction was given up as hopeless several generations ago and I was considerably taken aback to find it still alive elsewhere. But that also revealed what I had gotten myself into.

One of the irritating obstacles to the full incorporation of the arts into the generality of the work of the mind is the inability of the non-art people to see that art deals with fundamental issues. It is considered an enrichment of the humane life, an extension of the forms of feeling, a symptom

of movements of the mind (and, therefore, a diagnostic instrument), a reflection or illustration of ideas. It is not often considered a fundamental thinking about fundamental ideas. Having expended a great deal of effort trying to extricate art from the consoling embrace of theology and philosophy, this definition seems to deliver it over to another auxiliary function, that of an exegetical instrument at the service of story.

In fact, art *is* such an instrument, just as it is all those other things listed above. No human activity of worth is two-dimensional. My duty will not have been done until I have demonstrated a little of what art can do as an instrument of interpretation. But that comes later.

Again, I have evaded terminological issues. I have not defined "hermeneutic" but contented myself with words like "exegesis" and "interpretation." But a hermeneutic is not just interpretation. It is more fundamental than that. As I propose to use it, hermeneutic is the setting forth of the materials and conditions within which any human act was engendered in order to see that act in its fullness. Thus, art as a hermeneutic of narrative is the setting forth of the fullness of the human situation which is the narrative and which generated the story. It is the function of a hermeneutic to make the narrative present to us so that the work into which the narrative emerges, be it story or painting or symphony, can exert its full force on us. Thus, the primary function of a hermeneutic is not to elucidate or expound the particularities of a story (although it must not try to avoid doing so) but to set out the structures which come to formal statement in the story.

The distinction between narrative and story may be dramatized by a further observation: seldom if ever does a major literary work receive its illustration in an art work of consequence or find in a major art work an important in-

terpretation. Major artists have sometimes addressed themselves to major literary works: Botticelli illustrated Dante and Delacroix based paintings on Shakespeare. But in neither case do we deal with a crucial part of the artist's oeuvre nor is our understanding of the literary work particularly advanced by the illustration.

Where art does serve as exegesis and hermeneutic of narrative concerns two quite different blocks of material: the acts of the gods as set forth in the basic scriptural material of a culture, and popular stories, legends and the like—lives of the saints, miraculous stories, heroic deeds, etc. As divergent as these bodies of material appear to be they have much in common. The stories of divine order (set down canonically for western culture in Homer and the Bible) are not stories as I have defined story above. Rather they are the prime narrative itself. The bones and muscles of the forming narrative are there displayed and they engender the forming imagination of the artists who find them inexhaustible. Thus Sophocles could turn three times to the Oedipus myth and Giotto could devote most of his working life to the Bible.

The popular stories and legends on the other hand lead almost as surely back to the primal narrative. They are the products of simple minds working with simple, often outworn ideas that nevertheless do contain certain fundamentals. They may lack literary subtlety and literary quality, but they present blocks of simple emotion that can be analyzed to fundamentals.

The problem with major works of literary art is that they are already themselves a hermeneutic of the primal narrative. They possess power precisely because they set out the primal narrative, in the fullness of its mystery, in forms that implant it in the imagination but preclude other forms.

Thus we do not have a "non-temporal" art interpreting the "temporal" arts, for no such distinction exists. Rather we

have arts engendered from the primal narrative and setting it out for the imagination in the completeness of its spatial-temporal structure.

Why, then, do excellent and responsible critics speak of narrative as essentially temporal? The answer lies within our own narrative which has engendered the very hermeneutic that addresses itself to narrative. Let us look first at the setting of our narrative.

No one can prove that climate and geography decisively influence culture but I am convinced they do and, on the basis of what I think I know about the human spirit, I would be most surprised if they didn't. Experience is enacted on the axes of space and time. Space and time appear to us first and primarily as the land and the seasons and the weather.

Western history is incorrigibly both Greek and Hebrew in its origins. I probably should say irreconcilably as well, for our imaginative structures have not succeeded in carrying those forces past an uneasy tension into a fruitful union. Christianity, which is incorrigibly both Greek and Hebrew, has repeatedly been torn apart by the force of this tension.

The kind of hermeneutics which has been developing in the church over recent years has tilted the balance in the direction of the Hebraic side of Christianity. The intelligence brought to the work is decidedly Hellenic but the concerns are the working out of the moral will in time—which is the definition of story.

The prime historical symbol of Hebraism and Judaism is a going out, a journey in time across a nearly featureless desert. Sinai and Arabia are the hinterland of Hebraism and the secret refuge of their imagination was the Judean wilderness, that incomparably noble, terrifying, harsh and barren land. In the desert and the wilderness, in limitless, powerful and unified space, only the will ensures personality. Faced with the relative prosperity of Canaan and the luxuriance of the Mesopotamian valley, the Hebrews would have been

swallowed up in the idolatry of the cults had they not been goaded into history by the ascetic will of the prophets.

Greece is different. Greece is great clear masses in the light, masses that are majestic but not terrifying, severe and clear. Greece has clear edges; a journey through Greece is a constant climb to the top of a ridge, a shorter descent to a plain which was the territory of an ancient state. Mystery in Greece is always the neighbor of light: the shrine of the Furies, transformed into Erinyes, in the stony flank of the Acropolis or the numinous cleft in the side of Parnassus that is the Castalian spring. There is always and everywhere this harmonious balance of clearly defined forms. It is accidental that the passion of the Greek enterprise should be for a small number of clear and simple but fundamental ideas? Knowing many architectural forms, they were content with one architectural idea, subtly refined, its possibilities explored and developed. "Iktinos invented nothing: he merely saw more clearly how things should be," says Rhys Carpenter.[2] And ". . . there is a true form for every class of objects and that such a true form is characterized by its geometric simplicity, by the commensurability of its component numbers."

Greece is a meditation on forms in space as Judea is a meditation on events in time. Even event, biography, becomes for Greece a spatial form; Plutarch could see earlier and later biographies as occupying the same shape, in part because men often saw themselves the same way and shaped their lives to a model already laid down in myth and history. Thucydides, the writer of the greatest of all historical works, did not at all write history as we know it for his is not an open and variable succession in time, each event shaped by a decisive will and generating the next event. Rather his history is a fixed and fatal shape in space whose end is in its beginning. The famous speeches, that profound essay in social psychology and political science, did not trouble much

about what was actually said, which, with all the greater at-
tentions of Greeks to oratory, was undoubtedly full of the
confusion, bombast and vulgarity of thought of all political
discourse. Rather, in them Thucydides set out what was *re-
ally* said, the shape of power, the structure of power, that
was only crudely manifested in particular words and events.

One of the best books on the classical idea is Philip Fehl's
The Classical Monument. Fehl uses a characteristic vocabulary,
"pathos," "modesty," "nostalgia," "moderation," "dignity,"
"harmony," "magnanimity." How we are related to these vir-
tues, he describes in this way:

> The images, however, invariably exemplify certain vir-
> tues which were claimed to have graced the life and the
> estate of the persons they honor; each one, therefore,
> shows us the image of a human being who, by his
> aspect, patently exhibits qualities which make him de-
> serving of our praise. At the same time, the image pos-
> sesses a certain individuality which convinces us of the
> uniqueness of the person it represents, and thus moves
> us to regret at his passing.
>
> In one way or another the comprehension of the
> uniqueness of a human life is, perhaps, the source of all
> gentle feelings for our fellow men, and ultimately the
> source of civilization. In the contemplation of antique
> statues this comprehension is heightened and ennobled.
> Inasmuch as each work demonstrates and celebrates an
> admirable quality, it invites our sympathy and affection.
> Above all, however, the antique works are themselves
> models of the contemplation they elicit; . . .[3]

Fehl's vocabulary tastes like straw to many because his
listed virtues do not, for most of us, exist as things but only
as qualities of persons. Since what we want is the person and
not his qualities, the virtues become congealed into the plas-
tic copy of a neoclassical mask. But, in feeling so, we miss the
point of the classical enterprise, whose voice Fehl is. Note
that we first see the exemplified virtues. There is only so

much indication of the individual as will serve to remind us to whom our praise should be directed. We regret, not *his* passing but the loss of the occasion for the virtue which he manifested.

It is a long way to the mourning soldier at Warm Springs, speaking of Franklin Roosevelt, "I always felt he might have known me." And then, shyly, "I thought, if he had known me, he would have liked me." We admire and praise Washington and Jefferson, whose public lives were modeled on an image of virtue. But we love Lincoln, whose equal virtues were secondary to a humanity that was altogether individual and deeply personal. It is, perhaps, a difference of temperament that determines which will teach us virtue more securely.

One of the implications of what I am saying is that a hermeneutic in the characteristic language of art must draw for its fullest development on all the formal languages and not just those that depend for their designation on a one-sided view of what narrative is. Art can define character and relation, intensify or quiet the rhythm of an act. Art can clarify an act beyond the possibilities of story because those things which must be set out in succession in the story can be shown, simultaneously, in a painting. These things are a part of interpretation but only a way station on the road to a hermeneutic.

Since a narrative is enacted in space-time, a hermeneutic must set out that space-time in order to enable the narrative to present itself in the fullness of its reference. That means that the rhythm of the event in time and the shape of the event in space are of equal importance. Thus architecture is an essential part of a true hermeneutic although contributing nothing at all to the interpretation of story, for architecture is the rhythmic ordering of masses in space and thus sets out, perhaps more clearly than anything else, the essential narrative.

Our hermeneutic, as our own narrative, chose to concen-
trate on time because we are children of the Sinai desert and
the biblical ordering of time. More immediately we are chil-
dren of Augustine. Augustine himself came out of the space
world of classical antiquity and his image of redemption is a
city, not an exodus, but the city is reached by a pilgrimage
and his *Confessions* is the first, and still perhaps the greatest
of the meditations on time and memory. It was necessary
that it be so, for the landscape of classical space was cluttered
with dead shapes and to build anew it was necessary to build
differently. And so began the pilgrimage through time.

I do not know if the death of our cities caused or was
caused by the death of the City. But they have died, and are
now imprisoned in time as Augustine's world was impris-
oned in space. Instead of a pilgrimage to a goal we have
only a purposeless energy or that deadness of spirit that the
ancients called acedia.

There is no return to a spatial world, any more than there
can be, for us, any flight into the denial of time or space.
What we do is learn what our culture is made of. The clas-
sical world was the most prolonged and intensive meditation
on shapes in space the world has ever known, needing only
to be balanced with the great Chinese reflection on space as
void. Christendom has been the most prolonged and inten-
sive meditation on energy in time, needing to be completed
by the Indian account of the timeless and non-dramatic en-
ergies of the fertile flesh. But Christendom (which is still the
mythic world of the west, even for non-believers) is as firmly
rooted in classical space as it is in Jewish time. As a culture,
we have obviously known that and our ideas and our institu-
tions owe as much to Greek thought as to the Hebrew idea
of the moral will. Our artists, for five hundred years, knew a
great deal more. But the culture, the work of the western in-
telligence, took that too much as ornament, as furniture, not
as central to the intellectual enterprise. It is there as a re-

source. Nowhere else, unless it is in Japan's meditations on the meaning of Chinese forms, is there so profound a meditation by one culture on the meaning of the forms of another; and to recover the sense of what Greece and Rome stood for, we are going to have to recover a sense of what the Renaissance was up to.

We do not, at least yet, have an Augustine to do for space what he did for time. But we do have resources that he did not have. We can only make a beginning since we don't have an Augustine and the beginning will take the form of an examination of several works, stories, themselves a setting forth of the ancient narrative.

Let us look first at the western pediment of the Temple of Zeus at Olympia, the story of the battle between the centaurs and the Lapiths (fig. 1). The story is simple and clearly and simply presented. Up to a point, it can be taken as an apt illustration of the laconically told events of all sagas and myths: the drunken centaurs are attacking the girls, the young men are fighting the centaurs and Apollo is standing invisibly in the center, tilting the balance of the conflict toward the Lapiths. Myth and saga have this laconic quality and it is precisely that which creates room for the linking of story into narrative. The myth states the story, the mere event without interpretation, although the story must always be such as to contain, linked to the narrative structure, the possibility of being many stories. Thus Sophocles could extract three different Creons from the same myth, Kierkegaard could find four Abrahams. The creative artist is always bringing the narrative to life in the immediacies of our experience.

Pay particular attention to a very small point—the corner of the mouth of the Lapith whose arm is being bitten by a centaur (fig. 2). But I must circle in on that point.

It is quite standard in interpreting these figures to point out that there are two clearly distinguished types of emo-

tional expression. The drunken centaurs are passionate, faces twisted in rage and lust. The humans, in contrast, are calm, sternly disciplined, controlled. Clearly, for this artist, the story was not simply a tale to be illustrated but a part of the sacral narrative. The centaur is the bestial side of the human and drunkenness is bestial because it destroys the control which is required of the truly human. Apollo, on the other hand, is the fulfillment of the human, all majesty, clarity and purity. The strength flows from Apollo into the Greeks who became, then, epiphanies of the god.

A myth can be told as a story, charming and entertaining. It can be told as narrative and, as the narrative unfolds, the gods are formed. It is the function of art to bring the gods into being from the great, rugged chaos of the myth.

So noble an aim is not likely to be achieved by so simple a distinction as the expressions of faces, as important as they might be. There must be—and there is—something far more important going on.

Whatever conception we have of space, we can suppose that space itself is homogenous and infinite. We must accept the "suppose." We never experience space directly but only through a culturally determined image of it. But we can suppose it so. So abstract a sense of space is not easy for anyone, particularly an ancient Greek, to imagine; he would have thought of it as nothing. The Greek inherited the primary organization of space from the Egyptians. The primary divisions of space are the fact of the vertical and the horizontal. With respect to ourselves (and, correspondingly, any upright body) there are three primary axes: the vertical, one horizontal that is parallel to the breadth of our body, and one that goes front to back. Since there are an infinite number of points from which these axes can be constructed, space is defined as an infinite, homogenous web, or framework or cage (Kaschnitz uses each image) of intersecting horizontals and verticals.[4]

The Egyptians were content to fit their imagination into this framework for nearly 3,000 years (fig. 3). Their statues were cut from stereometric solids. The four main views of a figure were drawn on the four faces of the solid in a two-dimensional grid and the four drawings simply cut back till they met. An angular view of Egyptian sculpture is not a true angular view; it is a wrong view. Stories, too, are fitted into this framework with considerable vividness but no narrative intensity and certainly no moral depth.

Mention of the Egyptians shifts the tonality of this story, for with them we move into foreign territory. The Greeks are no longer as immediate to us as they were to our grandfathers or great-grandfathers. But there is still an immediacy in our relation to them because their forms or the semblance of their forms are still around us.

This not only is not so with the Egyptians but it cannot be so; one of the strangest aspects of the Egyptians is that their essential achievements are so inescapably foreign to us. They have had less direct influence on our imagination than any other of the great cultures and so they do not participate directly in this story.

But it was not so for the Greeks; the Egyptians were the great mountain range that closed off the landscape of their imagination, or, to rely on a somewhat more passive statement, they learned the art of sculpture from the Egyptians. What they learned they absorbed and transformed so we see little that is Egyptian in Greek art but hidden within the Greek achievement is a fruitful seed that is Egyptian.

Furthermore it fell to the Egyptians to be first in two essential acts of the human imagination. They invented the vertical and they organized space.

To speak of "inventing" the vertical may sound nonsensical since the vertical is a part of the ordinary experience, even of the primitive villagers who preceded the high culture of Egypt. Yet it is not simply flamboyant speech; the

Egyptians invented the vertical as the dominant symbolic dimension.

This was one of the decisive moments in human history. It provided the framework within which the human imagination has worked itself out until our own day. It has been one of the primary means of organizing the human mind.

It is not difficult to tell why the vertical suddenly became so important; the only problem is in telling what preceded what. The gods moved to the sky, the pharaoh as the god-on-earth moved up under the abode of the gods and the symbolic primary of verticality was established.

Prepositions and adverbs are marvelous things for understanding the symbolic order. We speak usually of God as "up" there and direct our devotion skyward. We speak usually of the "higher" cultures or refer to "the church from top to bottom" or "the university from top to bottom."

Here history and reality conflict. The inescapable fact is that hierarchical order built on the prime symbol of verticality has been indispensable to the development of civilization. At the same time hierarchical order has nothing to do with the reality of either the university or the church; the most cursory awareness of Hebraism should make clear that it is blasphemous to locate God anywhere. Furthermore, modern science has destroyed verticality. Where is "up" from a round earth floating in an infinite cosmos? Of such material is modern schizophrenia built.

Thus in considering verticality as a symbol we must remember that we are not dealing with a fundamental truth of experience or a constituent element of our psychic structure. We are dealing with one of the earliest and most powerful of the primary symbolic orders. Symbolic orders are not arbitrary; they emerge from the interaction of humans with the experience they are placed in, using the equipment they have. But when the people change the symbols will change and we will have to contend with that problem later. In the

meantime, we have met one of the first great symbolic structures, one that determined the human imagination for nearly five millennia.

This dominant verticality carries with it an inevitable corollary; the establishment of the vertical requires an awareness of the horizontal. The Egyptian imagination had conceived the vertical in cosmic proportions. (The popular instinct that makes the pyramids a sign of Egypt is symbolically perfectly accurate.) The horizontal generated from this power of the vertical had to be equally imposing. In effect, therefore, the Egyptians' symbolic imagination ordered an entire landscape around its center.

For us, a consequence of this is that the Egyptian public imagination is almost inaccessible to us. I say "public" because we have no reason to think that the ordinary private imagination was greatly different from our own. This is, indeed, the problem of all study of history. We are dependent on the accidents of survival for our evidence and what survives is usually the large public monuments, not the evidences of private life. The life of Egyptians would have been worked out in bedrooms, corridors, courtyards, gardens, streets, and these would have imprinted themselves on their imagination as our own settings do for us. But their high art has none of that intimacy nor is there, until Roman times, any symbolically effective interior space. Architecture is the organization of exterior space and nothing so decisively separates us from the ancient world as this fact.

The Egyptians deserve better than this brief statement. Their art is a profound essay on the possibilities within such a structure and deserves close attention. But, in this context, they are presented in terms of a symbolic device they passed on to the Greeks. Their public mythology was built around an image of public order which was organized according to a geometric grid.

The Greeks inherited this space cage from the Egyptians.

But early on they felt an equally powerful interest in the fact that the human body, which is organized around such intersecting axes is not, in fact, defined so exclusively by the consequent geometric planes but by energies that are set out not only in swelling surfaces (which the Egyptians knew about perfectly well) but in the swelling surfaces locked together by joints, crossed by muscles, suspended on an articulated skeleton. The drama of Greek sculpture is the pressing of this organic vitality against the confines of the bounding planes. Till its end Greek sculpture of good quality never lost the sense of the governing axial framework, however emphatically it may have broken through the bounding planes. In the early days, there is an extraordinarily powerful sense of great energy compressed into strictly controlling surfaces.

This is not story; but it is in touch with the narrative as I have defined it. In archaic sculpture (fig. 4) it came through more powerfully in single figures than it did in stories. The participation of the spectator is intense; as he stands in front of an archaic statue he cannot help being intimately aware that the front-back plane which bisects the figure bisects himself as well, that the transverse plane is parallel to a plane that bisects his own body. Figure and spectator are placed in the same grid and the ordered energy of the figure reproduces itself in the ordering subconsciously imposed on the spectator.

This grid is defined initially (we can only guess) not by sculpture but by architecture and, before that, by the landscape. It is not difficult to see the shape of the Egyptian landscape in the shapes of the Egyptian imagination, the featureless desert bisected by the single strip of the river, bounded by the horizontal line of vertical cliffs. Greece is not the same. Verticals are there, aplenty, but not quite so clearly set out as in the sheer cliffs of Egypt. The horizontal is there in the sea, the plane surfaces surrounded by hills,

the flat top of the Acropolis (fig. 5). Pure horizontal and vertical can be felt within the natural forms which swell out around them in organic coherence. Greece is stonier now than it was then, before centuries of attack on the forests, but the difference can't be decisive; the coast swings in its powerful waves around the edges of the land, sailors still make landfall on the peak of Sounion.

Thus the land is held fast by the grid. A point is defined within the grid by some centering of mystery. The grid is then organized, given direction by the shape of the land-scape and the procession that winds through it, given a modular definition. The architect had then only to fit his temple into the appropriate module. The verticals and horizontals were there to be felt and the stone laid along them slightly curved, delicately modified, to give the great Greek energy to geometric definition.

Within this sacral geometry there were two areas of special clarity of emptiness: the prismatic form of the naos, which was the space for the great cult image, and the tympanum of the pediments, whose sloping edges defined a primal trian-gular shape. Thus the eternal and unmanifested geometry, seized by the shape of the land, focused on the darker mys-tery of a place, finally sets out a basic shape for the sacred narrative.

This space is far from neutral but is charged with the in-tensity of sacred power. With extraordinary grace, the sculp-tor at Olympia (fig. 1) runs his forms along the lines of the sacred geometry. Even the writhing centaurs are fitted to the framework of axes though counter to the movements that center on Apollo and which derive their saving grace from the Apollonian light.

It is hardly too much to say that the clear light of the Acropolis, the awesome majesty of Parnassus, the mystery of the Castalian spring, are not simply condensed into Apollo.

They created Apollo, who could not have been born in any other landscape. But it is the responding reason of man that captured the glory in the strength of the geometry.

All historical writing is presumptuous in its claim to reconstruct a vanished way of life from the fragments of evidence that survive. It is presumption in the extreme to think we might reconstruct the response of the spectator to whole works of sculpture, forty feet up, when all we have are broken fragments, reconstructed by educated guess inside a museum. Yet the spectator is integral to the work and, if we rely less on expression (which is so closely bound to time and experience) and more on structure, we might say something of use. For the spectator—no, the devout visitor, for the spectator only sees the work externally—receives into his own body the powerful geometry which organizes his own space, the space he occupies within the whole landscape. Equally, he feels the play of organic drama around the powerful geometry and the appropriate response is the ennoblement of his own soul to the image of order overcoming chaos.

It is of the nature of the recording of myths that they are not only laconic but uninterpreted. They come to us as unadorned event. A bookish people such as ourselves tend to forget that the late written record we inherit has little to do with the original myth and, in fact, can be considered little more than scenarios for an enactment. As presented, the myth always had form and, therefore, content. Lacking all the other true forms, other than the written words of the epic, the stories come to us most surely in the great forms of the temple and the sculptures which emerge from the forms of the earth and make the landscape humanly intelligible.

But I said earlier that I wanted to focus a certain attention on the corner of the mouth of the Lapith youth whose arm is bitten by the centaur (fig. 2). I should like to add the space just above and between his eyebrows.

I would assume that these areas were not really discernible from the ground, even with the help of paint. Yet the sculptor felt it necessary to include them. They represent an undoubted fact. Under the impact of sudden pain, deep grief, or the like, the muscles of the cheek tighten, drawing back the corners of the mouth, and the muscles of the forehead similarly tighten, wrinkling the forehead. I learned how involuntary this action is when I was driving once through a wooded region in the summer. An animal had died and, escaping the buzzards, had decayed and a powerful stench filled an area of the road. At the speed of the automobile, I could not have been exposed to the odor more than a few seconds but my muscles tightened exactly this way and remained so for a good two or three minutes.

All art is nourished by some experience of the world as it is lived outside the experiencing self. We tend most often to forget this when we look at ancient art for we see it through the neoclassic imitations of it, interpret it through the frigid formulas their forms were reduced to. But the sculptor of Olympia was not John Flaxman and it is well to remember always the great comment on all neoclassicism: "The only way to imitate the Greeks is not to imitate the Greeks who never imitated anybody."

This sculptor had experienced the natural order as true artists do. He had seen the natural body, felt its energies and could record its natural life, to the extent of recording its physiological act. Thus, inadvertently (how do I know it was inadvertent?) he has underlined the care and deliberation of the rest of his assertion. It was no part of his intent to give a journalist's account of an imaginary event. The Greeks did a great many things, rather than nothing, in excess, and in their passion they often showed little knowledge of their selves, certainly not of their selves' limitations. The whole myth they are telling here is a brutal, bloody affair full of cheating, lies, murder, lust. We have no way of knowing

what the myth meant to those who originally knew it. All we can say is that it meant this to the artists who placed it at the confluence of enormously powerful forces and thus made forms from which an equally powerful narrative emerges. So we should look at the face behind the involuntarily grimacing gesture or look at the Lapith girl who is being so brutally assaulted, yet is maintaining her glorious, humane dignity. The sculptor knew the movements of muscles under the skin—see also the infinitely expressive gestures of the hands—so his transcendence of ordinariness is purposeful and not a cutting of experience to the inertness of inherited patterns.

This telling of the story is not in the least an illustration of it; in fact, from the simplification of forms, the isolation of figures from setting, it is not even a particularly good illustration. Instead the artist has extracted from it a particular reading which he sets out in powerful and effective forms. Even more, it is not a representation, something ancillary to a document in another language. It is, rather, a presentation that permits a basic human theme to become manifest in the immediacies of the worshipper. It is, therefore, a true hermeneutic.

The word "idealism," so commonly used, is quite inadequate here. The sculptor is not seeking to set out an idea or an essence, a principle which is more nearly derivative from the observation of sculpture than sculpture from it. Rather the purpose of the sculptor, knowingly or unknowingly, would appear to be to make Apollo present, to summon Apollo in his very being and actions. I would go further, abandoning the attempt to articulate the intent of so distant an artist, and simply say he has made Apollo present. It does not do to deny the great gods. They are inherent in our organism, in the patterns of our behavior and relations, in the ordering of both landscape and history. It is the intersection of a place with a culture and a history that engenders the

particular form, the name of a god. The Greeks themselves seem to have been singularly aware of this: Apollo at Olympia shares a narrative with the other Apollos but Apollo of Olympia is not quite the same as Apollo of Delos or Delphi.

It is not simply the figure that represents Apollo that incarnates him; for it is conceivable, although highly unlikely, that it doesn't even represent Apollo. It is, rather, the whole work and specifically the structured tensions within it which are captured and constrained by the forms of the sculpture setting out the forms of the narrative. Nor is it so simple as making Apollo manifest to the admiration of the spectators, for the spatial transaction that is Apollo is incomplete until it includes the spectator. The Apollo narrative is not exhibited in front of the spectator; it is enacted in the world of the spectator, aware of the particularities of that world but both transcending and transforming them. The spectator completes the act of the narrative and is, therefore, incorporated into it.

It is for these reasons that I have extended the word "narrative" beyond simple "story." Underneath story, as underneath belief, there is a powerful, controlling sense of the order and purpose of life on earth. Abstractly these might be subsumed under the headings "geometrics" and "dramatics" but we meet no human situation abstractly. We meet them in their wholeness when drama and geometry and purpose have been fused into a whole. That whole is the essential life of a people. Presumably the modish word "image" would suffice to designate that picture which constitutes a people's world. I chose narrative because "image" is inevitably too static. The narrative of a culture necessarily includes a definition of purpose and movement toward that purpose which is a movement in time—and time is an essentially narrative act. Furthermore we enact our own personal narrative in the frame and according to the symbols of the corporate narrative.

Yet structure may be as appropriate a term as narrative. It probably won't do to substitute it, for its meaning is colored too much by current uses that have nothing to do with its use here. But "structure" is corrective to "narrative," not only in that it shifts the meaning to fit better with the vision of the more static cultures but also because it emphasizes that aspect of our life which is indifferent to time and to that quality of time which is acted out in space but does not determine it.

Much of this is no longer evident at Olympia; the temples have disappeared and the sculptures are only fragments in the museum. But the Parthenon (fig. 5) is more nearly intact and sets out the same basic ideas. It would be closer to the truth to say the Parthenon is almost intact, a statement which would grate strongly on the ear of those who have seen the shattered hulk of the once resplendent building. That, however, is an attitude which grows out of a metaphysics of things—reality as objects—which is not the ancient attitude. The Parthenon is the focus of Attica and the great hills and the sea are a part of the Parthenon as the marble walls and the naos are. So the Parthenon begins at Eleusis with the beginning of the procession. The Sacred Way is a part of the Parthenon (or was; much of it is a truck route now and denies the Parthenon). The Acropolis made the building of the Parthenon a necessity. It is, above all hills save one, high and lifted up. It is not a high hill, not nearly so high as Mt. Lycabetus a short distance away. But Lycabetus is only a high hill. The Acropolis is lifted up above the earth, under the sky, and it requires the Parthenon as the fulfillment of the relation between earth and sky, the manifestation in a disciplined human act of the abiding order of things.

As a substance the Acropolis is of the earth and the procession went by the shrines of the dread deities of the earth; the sun-filled glory of the building did not obliterate the reality of the ancient powers. Aeschylus had Athens victorious

over the Furies but faithfully respectful of them. They are forever there, in the earth. The Parthenon itself summarizes this quality for it is truly a dangerous building. It is often described in terms appropriate to a neoclassical bank, which it is not, nor should either sentimentality or obtuseness be allowed to obscure what it is.

The famous "optical corrections" (the curvature of the columns and the stylobate, the adjustment of the space between columns, etc.) are not at all motivated by any such considerations, if we can identify intention with effect. Rather they turn inert support into organic supporting, gather the great mass of the building into the tensile interaction of a living body. A terrible strength emerges from the depths of the marble to be held in control—just held—by the cage of verticals and horizontals that has been composed by human intelligence. The famous balance and harmony of the classic is not, in the Parthenon, the dull symmetry and dead order classicism can be in insensitive hands. It is a balance, a precarious balance, achieved against the dreadful strength and energy of the earth, the appalling energy of Achilles and Alcibiades, the energy of the earth and of the natural human below or outside morality. In history, the force of Achilles and Alcibiades took its terrible toll and destroyed Greece but, in the Parthenon, for once the energy was brought under control of intelligence and moral will. Thus the human and the earthy are a glory under the sun.

After reaching the building, the procession went along its flank to make sacrifice at the altar on the eastern steps. However we would like to do so, we cannot reconstruct, we can hardly imagine, the sensation created by the worshippers as they moved parallel to the stately sculptures of the true Panathenaic procession which they themselves were bringing to light as the sculpture did. Simultaneously the two processions arrived at the eastern end, the living procession to the altar of their sacrifice, the stone procession to the gods

seated on Olympus, the true procession (something other than both but manifested in each one) coming to being in both.

It was a moment rare in human history and all the more precious for its rarity. It is a moment of balance but not a static balance. Rather it is the coming together of the fearful energies of the earth and the majesty of the sky, concentrated into the building which is the most intensely human of all visions. It was Athena made manifest.

It was not enough. Every chronicle of human achievement is at the same time a chronicle of human failure. The Parthenon, the noblest expression of religious humanism, was built with stolen money. While the Parthenon was being built Athens was doing such things as can shock the conscience even of the cruel and bloody twentieth century. There is no true way within the Parthenon to account for the cruel evil that permeates the world.

There is also no true way in the cruelties, mendacity and deceit of the world to explain away the Parthenon. In the presence of the Parthenon we are for the moment in the presence of Athena and all that Athens meant.

three

PRIVACY AND THE
BIRTH OF THE SOUL

"**P**lay me a tune on an unbroken spinet," said Thomas Wolfe. Or what did the workmen say to each other as they ate their lunch sitting on the unfinished columns of the Parthenon?

"History" is a record of public acts. But life is lived in privacy and privacy leaves a small record. Ancient Athenians had their private lives which they lived out in gladness and in sorrow as do we all. But they have left little for us to know how they thought and felt about their privacy. Their art does not tell us—or there is none surviving that does tell us.

Perhaps they were indeed more public men than we. This time "men" means men; it was the men who lived their lives in the streets and the agora whereas the women stayed at home with the children. If they lived so publicly, their life in the halls of the women only a dim memory, perhaps they did not fully develop the capacity to be private. We cannot know. We only know that for a long time there was no art that revealed a sense of the soul's solitariness and that has survived to us. When it came, it came late and my chosen example is in a different medium and mood.

Such a choice itself prejudices the case. The case might be fairer were it to follow through with a companion study of

sculpture on public monuments. The only excuse is not to make too large claims for the comprehensiveness of the conclusions. Let us, therefore, choose a painted narrative in a private home, and even try some very tentative conclusions, while remembering that we know nothing at all about painting in the classic period.

Actually, the choice is not really haphazard. If I am right in assuming, with most historians, that the Greek imagination was primarily sculptural, then the clash between a customary mode of thought and the inevitable and inescapable mental construct that inheres in a different material will have reverberations through the personality.

Such Greek painting as survives does, in part, appear to be subject to the idea of sculpture or to the idea of the stage or, perhaps, the stage conceived sculpturally. That is, the emphasis is on carefully modeled, three-dimensional bodies, in the formal attitudes appropriate to a stage. Space is neutral, simply containing the bodies. Objects are few, as might be appropriate to a fairly economical or ascetic stage production. It is not this tradition of Greek painting I want to look at. To non-specialists it appears to be just what most of it is, pleasing room decoration. This may be an unfair conclusion; nearly the only thing we know about Hellenistic painting we know from copies and adaptations made for rooms in private villas in Rome and the Campania so it follows that the themes were chosen to suit the taste of well-to-do Romans and, indeed, what is suitable for the decorations of a private home.

But, in any case, the evidence is consistent, and consistent, too, with the few literary records. It is consistent also with the evidence of monumental sculpture. A knowledge of the classical vocabulary as laid down in Olympia is quite sufficient to grasp these works. This statement appears to be an example of a general error which I want to condemn. Art historians have been much like political historians of an

older generation in thinking that the "real" Greece came to an end with Alexander and, with a few exceptions, Hellenistic art is considered good or bad according to the degree to which it approaches or departs from its predecessors. That is not the point. It is true of all Hellenistic culture that, if we would give up the principle of an ideal Greek mode represented by the fifth and early fourth centuries, we would find not only work of profound merit and significance but a profound commentary on the canonical period. Hellenistic sculpture is often itself an important (and conscious) hermeneutic of classical sculpture.

Thus it is possible to assert the independence and importance of Hellenistic art while seeing it, at the same time, as an extension of a common intellectual form. This is equally true in western art, which, despite its enormous variety, explores a common stylistic idea from Giotto at the beginning of the fourteenth century to Degas and Renoir at the end of the nineteenth century. The great public monumental sculptures of the Hellenistic period, the Mausoleum of Halicarnassus, the works of the Pergamene school (fig. 10) are quite independent in form and merit, yet add no basically different principle to that set out for Olympia. Essentially they are built around the human body conceived on a geometric frame. Narrative relation is carried by the actions of the body, now including a more fully developed action of the facial features as well as bodily movements which appear to be those of an actor in the theater. (This may be a distinction without a real difference; the stately choreography of Olympia was done at a time early in the movement from ritual dance to true drama.) (The question is, who influenced whom? What did a performance in a Greek theater look like?) The profound differences between the Pergamum Altar and the Parthenon are superficially evident at a glance and can survive a detailed analysis. But both are set out in the same language.

An essential aspect of that language is that, from the Siphnian treasury to the beautiful Pompeian red of the Villa of Mysteries, the background is either completely neutral, there because there is no way to avoid it, or it is an undefined wall against which the event is enacted by human bodies unaided by more than the minimally necessary indication of place. Paintings, fixed in the forms of a sculptural imagination, are not, as best we can judge, significantly different.

Yet the presence of a background in painting has its own consequence. In sculpture the background is behind the figures and can be left there if the artist chooses. In a painting it is quite literally on the same plane as the figures. The painting can be made and seen as an illusion of a shallow, three-dimensional space into which three-dimensional bodies are placed—read, in other words, as a sculptured group. But when what is actual in sculpture becomes an illusion in painting, the work done by the artist and the spectator is a very different thing. Neither may notice; the conventions of illusion are often accepted for generations, even centuries. But it would appear that somewhere in the development of Hellenistic painting, someone began to notice the spaces between forms.

There is a difference between noticing and using. I am deliberately not using here the famous Odyssey landscapes, one of the best surviving copies of a Hellenistic painting, because they seem to be primarily landscapes enlivened with an action. The narrative, therefore, tends to be swallowed up by the setting. But that is exactly the point at this place in the argument. There is a good deal more coherence to the space of the Odyssey landscapes than they normally get credit for but, to our eye, there is still a curious dream-like atmosphere. This arises from the fact that, however sketchy they may be, bodies are considered separately and there is no true spatial envelope to relate them to each other.

We have no way of knowing how these works were seen by

an ancient Greek; certainly not as our eyes, trained by the Renaissance, see. (We do know, for an analogy, that cultivated Japanese, not trained in seeing in western perspective, consider their own perspective construction perfectly coherent and orderly while finding western perspective strangely artificial). It is nonetheless true that the sculptural imagination has generated a different possibility; forms exist with nothing, no-thing, in between and the appearance of space as nothing, as mere emptiness, was consequential.

The consequences were developed by an unknown master, probably now a native Roman working in his own right and not copying Greek originals. If he was not himself a Roman, as many "Roman" painters were not, he seems clearly to have worked within the orbit of Roman ideas and Roman spiritual needs.

Between 21 B.C. and 11 B.C., a villa was built for Agrippa near Boscotrecase. It was extensively painted, after Agrippa's death, apparently by a leading court painter. The paintings consist of expertly done decorative motifs, some remarkable sacro-idyllic landscapes and several narratives, one of which, showing the story of the Wooing of Galatea by Polyphemus, I want to examine more closely (fig. 6).

What appears to be a canonical version of this story appears in Theocritus:

> Often his sheep would return of their own accord from their green pastures to the fold, as he sat on the shore, amid the seaweed, wasting away with love, singing all day of Galatea. He nursed deep in his breast an angry wound, a pain in his heart from great Cypris' bow. Yet he found this cure; and he'd sit on a rock, high up, looking out to sea, and would sing:
>
> *Pale Galatea, paler than cream,*
> *why cast your love away?*
> .
> *Come to me; come, and you'll never lack a thing.*
> *Leave the [green] sea to beat on the shore;*
> *Your nights will be better spent in my cave.*

There are laurels around, and tall cypresses,
there's ivy, dark ivy, and grape-sweet vines.
There's icy water, which densely wooded Etna
provides from her white snow, an ambrosial drink.
. .
No, lady, now were some sailor to come,
at once I'd learn from him how to swim,
then I'd know why you choose to live in the sea.[1]

The main elements of the Theocritean story are present in the painting: the flock of sheep, the lonely high rock of Polyphemus, his pipe, the land and trees, the waterfall, white Galatea. The painting is, therefore, excellent illustration. But it is more. (In the next paragraph I summarize and paraphrase the authoritative publication of the Boscotrecase frescos by Peter von Blanckenhagen.[2])

Every object within the painting is rendered with convincing three-dimensional naturalism, using the traditional devices of clear contour, carefully modulated colors, consistent light to model the forms, coherent perspective. Yet no such consistent representation can be found in the landscape. Scale and proportion are manipulated freely. Distances and intervals are, therefore, uncertain and it is rarely clear which forms are connected with which. Color is graded in intensity from foreground to background, suggesting distance, but the same green is used for sky and sea, suggesting an undifferentiated medium in which objects and events float in isolation from one another. The result is a startling combination of coherent representational realism and a dream-like fantasy or fairy land.

I have suggested that part of the space development in late antiquity may have begun with the observation by painters of the unexpected effects of the transfer of sculptural ideas to painting. Be that as it may, there is no reason to think this painter did not know exactly what he was doing. There are two conclusions to reach concerning his method, both a part of this argument.

In the first place, his formal method serves the interpretation of the story and not just the telling of it. There is a pitiable, ludicrous contrast in the hideous and ungainly giant wooing the lovely sea nymph. They do not inhabit the same world and he can never reach her. A Renaissance painter, with his consistent perspective space would have to indicate her rejection of him by dramatic gesture. This Galatea has only to sit, in her beauty, looking at us, for she is forever inaccessible to him. Color and space here serve the exegetical purpose.

A charming story, charmingly told. But there is more. In the upper right, Polyphemus is seen hurling his rock at the ship of Odysseus. Now, the ancient spectator was perfectly familiar with the principle of continuous narration, a frieze narrating the successive stages of an event with the same characters appearing repeatedly or a panel, showing the same figure more than once. So it must have come as something of a shock to realize that he doesn't have another example of the same technique; the story of Polyphemus and Odysseus has nothing to do with the story of Polyphemus and Galatea. Rather it is counterpointed against the main story to give it greater and more tragic depth. Partly it tells us what manner of creature Polyphemus was by reminding us of his brutal fate and thus accents the disparity between the brute and his forbidden love. But partly, too, it uncovers the fatality at the heart of presumption. Polyphemus yearns for the stranger to come and teach him to swim so he can join Galatea in her own element. The stranger came, all right, and destroyed him.

Returning to Blanckenhagen, who sums it up by saying: "It is no longer the illustrations of a story that did happen or at least could have happened, but the pictorial evocation of a particular psychological arrangement: the brutish simpleton craving for the alluring elegant woman."[3]

It is a long way from Olympia but the narrative base is the

same. The Lapith youth is a living person whose mouth reveals the observed immediacies of the shock of pain. His truth, however, is not in the particularities of what he is but in what he achieves, his ascetic discipline transformed into the serene power of Apollo. Polyphemus is the Brutish Simpleton, Galatea is the Alluring Elegant Woman, who exist within a controlling order which cannot be violated except on pain of destruction.

It is so very different with a work such as Rembrandt's Bathsheba (fig. 7). The coherent space, which we share, the particularities of form, the delicacies of facial expression, make clear that it is Bathsheba who suffers in the immediacies of her flesh, a flesh suffused with conscience, the tragedy of her fate. The model is Rembrandt's Hendrickje and, being so full of personhood, is not the Desirable Woman but Uriah's Bathsheba. No grave and general truth gives distance and public nobility to the tragic dilemma, for the whole situation is false. Bathsheba has no fixed place in a general order which she has violated by willful hybris. She is the victim of her own beauty which is an inseparable part of her humanity. And so the magnificent face broods, above the beautiful body, on the despair of the human condition. None of this is explicit in the story nor ever attainable by critical words. It emerges from the hermeneutic of the artist.

I said there were two conclusions to reach from the formal language of the painter of Polyphemus and Galatea. The first was that he used his formal means to interpret the story in a particular way, thus extracting from it one of its possibilities. The second has to do more nearly with what I have chosen to identify as the narrative.

All artistic structures must be defined both in themselves and in their relations to the spectator. We can define the structure of the Olympia sculptures in terms of their profound axial and organic structure that is so disposed as to involve the worshipper in the world and the act of myth. The

sculptures implant Apollo in the sensibility of the worshipper, take the spectator up with the Lapiths into the glory of Apollonian order. This same principle, in fascinating and instinctively varied ways, runs through most of Hellenistic art. Here we have something new, for the order of the painting effectively separates the spectator from the work. It also incorporates him and his experience; each form is consistent and coherent as it would appear to him were he standing immediately in front of it. Thus to wander through the picture is to wander through the ever-changing landscape of nature.

But there is no way to connect the world of the spectator with the world of the work. The world of the Olympian battle is the world of the spectator, cleaned of accretions and defined in its essentials. The ritual of the Villa of Mysteries is a purified extension of the room. This world floats in the mysterious dark. The sacro-idyllic landscapes of the other rooms are islands in a mysterious and unidentifiable sea of black or white. It is a fantasy world, a fairyland.

Again Blanckenhagen:

> Upon entering the small room the ancient visitor noticed at his left a large and rather dark panel in bluish green. As he approached it there emerged as though from the deep sea the mirage of a romantic landscape inhabited by two familiar figures from a charming fairy tale. The beholder lets his glance wander into this pretty country that seemed so like what he had seen and lived in nature. But soon he found himself in a different world where nothing happened but everything seemed possible. Released from the rules of his own experience he followed the signposts of a new order. So guided he did not lose his way but willingly and confidently entered a dreamland, an enchanted world, himself enchanted and dreaming. As he turned away, he may well have smiled at such magic, but he had experienced something which no previous work of art had led him to experience—no moral message had been conveyed, but one no less meaningful about the natural incongruity of love and lust, of nature's unconcern and nature's beauty, of the vastness of our world

and of the smallness and futility of our life, of the
power of art to console us, to enchant us, and to make
us dream.[4]

It is well to guard against being too solemn. There is a
place, however far it may be from Olympia, for pretty fan-
tasy, for enchantment and dreams. There was at the same
time, a serious, solemn and publicly consequential work
being done with Ara Pacis (fig. 8). But history sometimes
turns on small hinges. If one of those hinges is Ambrose
reading without moving his lips, there may be room for
these lovely paintings.

As Blanckenhagen so sensitively demonstrates, these
paintings are, in fact, the complement of the Ara Pacis, the
refuge which a busy public man could turn to for relaxation
and refreshment. As such, they should not be taken as some-
how symptomatic of large cultural movements. In the earlier
period, we know nothing of the private life of Themistocles,
but presumably he had one, a place he could go for rest, re-
laxation, contemplation. He may have had beautiful objects,
he may even have had something corresponding to repre-
sentational art. Certainly Greek vase painting reflects a more
private view of art than Olympia—but not a more private
style.

Nor should we make too much of the movement from
public to private art. It is inevitable that a movement from
the small, concentrated life of the polis to the dispersed com-
plexities of the metropolis will impose a greater concern for
private life while enabling a few people to give expressions
to that concern. The point is, rather, the *form* of that con-
cern, for we are dealing here with the history of conscious-
ness, which is the only true history, with the slow develop-
ment of the forms that enable us to be what we are. The
history of art is not simply the history of taste but the history
of the languages by which we communicate with the world,
the forms in which we cast both our public and private life.

We, the uncreative among us, may feel inchoate yearnings, a desire for role or meaning, but if the forms are lacking, the yearnings remain inchoate.

The point now is not the intention of those who commissioned the work but the achievement of the painter. Agrippa had the taste to have been able to commission the work and perhaps the intelligence to have grasped it. But Agrippa was a public man and probably more went on in these paintings than he could have reckoned with. Probably Julia would not have cared, beyond the stylishness of the ornament and we cannot guess about Agrippa's heirs.

The clue comes in the lovely final sentence of the Blanckenhagen quote above. These paintings do something that no other surviving work did and so they represent something new in human sensibility. That is, art is not now a public act but a way of generating a private feeling. It works on the inner life, stirs up both ideas and fantasies, stimulates memories. Blanckenhagen suggests that the sacro-idyllic paintings are an enchanted world which, nonetheless, can serve as reminders of the world of bucolic piety. He goes on to say:

> It is a novel message in the arts of antiquity, it is not for the multitude and not for the public but for the pensive educated private man who, worried by the state of affairs or troubled by the uncertainties of life, has come to the country in search of contemplation and the tranquility of his villa. In these landscapes he may recognize a world of divine stillness, at moments close to him but ultimately unapproachable, a vision, a dream, but one that smilingly gives life a new meaning and perhaps even peace.[5]

This is a dream that haunted Hellenistic man, giving pathos and poignancy to both public and private life. Sensibility was built on the structure of public order and art was established as an essential means of disciplining the sensibility to its participation in that public order. It does not here mat-

ter if the order is theological, as at Olympia, or political and
dynastic as at Pergamum. The distinction would not have
been important and perhaps not even intelligible to a Greek.

The narrative out of which Hellenistic portraiture
emerges is something else. Sheldon Nodelman says of one
remarkable work (fig. 9):

> Compared to a portrait conceived in the new Roman
> system, even such an accomplished masterpiece of late
> Hellenistic portrait art as the bronze head from Delos
> (now in the National Museum, Athens), with all of its
> quivering emotion and acutely registered involvement
> in the experience of the moment seems somehow re-
> mote, unreal. We behold, admiringly, an intense pa-
> thos, but we are untouched by it. The events narrated
> in a Greek portrait exist in an objectified, self-enclosed
> capsule of narrative time, a dramatic unity from which
> the spectator within his own time of ongoing events is
> excluded. For the subject of a Greek portrait, the spec-
> tator does not exist; totally absorbed in his own world,
> unconscious of being observed, he gives himself over
> spontaneously and without reserve to his action and
> feeling. The man and his situation are one; their
> seamless completeness is that of mythic time.[6]

For this splendid passage, Nodelman gives us the results
of his analysis but not the analysis by which he arrives at his
result. Without attributing my analytic procedures to him, I
would trace this effort back to the axial structure of the head
and the play of expressive action across it.

The sculptures of Olympia are designed around an axial
structure that is identical with the structure of the worship-
per's physical and spiritual world. Energy and structure are
in perfect fusion. Expression is left for the sub-human; the
only human expression is an involuntary muscular spasm.
The general order, the eternal truth, is all, and through it
the individual transcends his particularity. The relief of the
Pergamene altar (fig. 10) is, in principle, the same. There are
now dominant diagonals (at Olympia diagonals fall on the

relatively quiet 45° angle or are felt as deviations from rest) because energy is much more important to Hellenistic Greeks than it had been in the fifth century. But there is a hard framework of verticals and horizontals; the frieze develops against the neutral background and therefore is determined by a plane paralleling the principal plane of the spectator's body; the diagonals dramatize the ascending movement up while carrying the energy of the drama. Whatever the resolution of all this energy in the Telephos frieze, the spectator's experience of it is quite consistent with the whole of Greek art. Whether he faced it, walked up the steps paralleling its movement, or looked at it diagonally, the composition incorporated him into its action and, therefore, into its order.

Not so with the Delos head. The constructions of this head could only be Greek with its profound sense of organic life built around a powerfully axial structure. Only now we do not deal with a simple grid but a complex, star-like network of axes. There is the central axis which is always present in true Greek work but it breaks at the neck. The axes described by the features are doubly tilted against the old (implied) Greek frontal plane. The look of the eyes is along still another line. The planes of the face play against, not with this axial structure. At every point, this axial structure avoids the structure of the spectator's world and thus entirely excludes the spectator.

There is intense expression in the head but nothing at all to define it or anchor it. It is simply feeling, undefined feeling, reminding us (or me at least) of our own use of formerly transitive words as intransitive (we "communicate" or "relate" as an act without content or have a "meaningful relationship" quite apart from what the meaning might be).

It seems unreal, remote, to us because it is not directed at us to share or at anything else that might define it and make it possible for us to participate in it by empathetic observa-

tion. It is simply feeling, solipsistic feeling without definition or purpose. I can, with Nodelman, see this head as a part of the myth—but the myth emptied of public order. If I may go beyond evidence or convincing argument into impressionism, I would say that this man has plenty of feelings but has no idea what to do with them, an inner life but no publicly organized system of symbols, no symbolic structure, to give it shape or direction. It is, simply, there, uneasily, fearfully.

The response is, of course, the history of Hellenistic sensibility. Then, as always, there were people content to repeat ancient pieties and live decent, orderly, unspectacular lives. The mass of people were, presumably, as the mass of our people are, lost and bewildered. A few could build personal systems and gather a small following. There were the expected counsels of stubborn endurance or techniques for establishing an island of private order, or counsels of private morality as the source of personal integrity in the decay of public order. There was the public cult that perverted the Olympian principle and made petty despots into gods. Underneath, like a river under ice, there was the turbulent search for a symbolic order that would give form to feeling, a search that centered on revived mystery cults and imported religion.

The Augustan age is a crucial transition, joining the Boscotrecase painter and the sculptor of the Ara Pacis. Nodelman goes on to demonstrate the nature of the Augustan achievement in art (and I have no hesitations in using the word "Augustan" as causal rather than chronological only, for Augustus had his sculptors fuse the native Roman vocabulary, which was so well suited to set forth the public virtues, with the formal structure and the organic energies of Hellenistic art). The result was something quite new, an unparalleled richness of public and private art which Nodelman summarizes as "the will to reach out actively into the world

of on-going life and to accomplish specific purposes within it through psychological modifications imposed upon the observer . . ." [7]

This mention of the newly defined public, or state, narrative is all that is needed in this argument. It worked for Augustus and for Hadrian but froze as all things do. The private life went on, as we can see through the extraordinary development of Roman portraits, showing the same vigor, finally violence, of feeling till Diocletian invented the Byzantine state as the artists were inventing Byzantine art.

My concern is with the paintings. The portraits continue to express feeling, unable to affirm a corresponding order to shape feeling. Our painter doesn't either. His represented world is a fantasy world that we cannot truly participate in. But, in so deliberately and consciously arousing feelings, definable feelings, he himself had to know a good deal about them and, furthermore, he was compelling the spectator to contemplate, not simply the paintings, but his responses to the paintings and thus learn what feelings were like.

It is not simply clever to say that it was an epoch-making event when Ambrose read without moving his lips; he was reflecting the fact that reading was now a private experience and not a public performance (reading had remained public in form even when the reader was alone). Human life is always both public and private and one task of culture is the relating of the two. The Delos head is the expression of the split between the two; the inner life had no shape because it was cut off from public life.

The Boscotrecase painter remained within the Greek grammar; his story presents formal types and not individuals. But, in acting as he did on the spectator, he created a wholly new possibility. Making a painting which is designed to create an emotional response in the spectator creates a quite new and unique sense of the self that can lead directly to Augustine's reflections on the self.

There is a long way to go till Rembrandt. If there is any immediate succession in painting, it has not survived or I am not aware of it. Opportunities for such civilized reflection became fewer, although Hadrian's Villa at Tivoli is hardly conceivable except as the conscious provision of a highly sensitive and wealthy man for the various states of his own inner life.

If we consider all this as the crisis period, the kind of psychological crisis that occurs when an inherited world dissolves and a new one hasn't yet impressed itself on the imagination of people, the question then becomes, what is the world hidden within the old one? It's a commonplace to say that a contemporary observer would not have known and might have predicted that the world would belong to Mithras. We should never forget that as we look back from the known result. But we can look back and find the seeds and first flowers of what was to come.

Paleochristian art was such as hardly to belong in this chapter. In its beginnings it is not a continuous development with classical art and if we are to look at a sketch, even, of a history of human sensibility we should assume immediately that a complete break has taken place. The Boscotrecase paintings are related in orderly descent to the sculptures at Olympia, however different they may be, but early Christian catacomb painting (fig. 11) shares very little with Boscotrecase.

Yet we are dealing with a phenomenon that does not lend itself readily to the evolutionary formulas of art history. The movement, instead of being linear and genetic, is an emergence upward from a lower social class. Generally speaking we have no access to the imagination of lower classes; they are unable, for economic or educational reasons, to leave a record. The Romans did rather better than most because their piety required images of their ancestors. The very poor had to content themselves with wax but there

are many terracotta and stone portraits of extraordinary veri-
similitude, calling to mind that corner of the house of every-
one's aged aunt containing the photographs of all her rela-
tives. So the people of the lower classes were accustomed to
images as a part of their lives, at least to a degree.

It is precisely these classes that were first attracted to
Christianity. As, over a period of time, the upper classes
began to become Christian, they were able to employ artists
who had catered to their class and we have then the fascinat-
ing art historical problem of the effect of new wine in old
bottles. But this is not a history of art; it is a sketch of the
history of sensibility and, curiously enough, the new ideas
can be seen in the earliest catacomb paintings.

Catacomb paintings (fig. 11) sometimes appear to have
been done by amateurs or perhaps the local sign painter,
certainly not by a trained artist. Yet neither is it folk art, the
spontaneous art of a people who know nothing beyond their
own inherited designs. Imagery was everywhere in ancient
Rome and the people who made these paintings did not and
could not have an innocent eye. But they were not making
images for any purpose belonging to the classical art we
know.

They were making visual prayers. It is not that they were
making pictures of people praying, although there are many
examples of exactly that. They were making prayer present
and enduring on the wall.

"Prayer" is not the usual word. The usual word is "sym-
bol." But "symbol" is a highly complicated and difficult
word. Maybe we can get at it better if we identify the specific
symbolic mode of these paintings.

I would appear here to have departed a bit from my initial
plan which was to concentrate on those artistic ideas that are
successively or progressively added to the repertoire of
human imaginative speech. There is certainly nothing
unique about the early Christian use of symbols, which goes

back to the earliest art, nor in the use of symbols that communicate with the sacred or the divine. We cannot say if there is a different modality of attitudes or use, for the only evidence for that is long gone.

Nevertheless, I am convinced there is something new at work here and an attitude that we might be able to reconstruct a little if we are exceedingly careful.

In Paul Tillich's classic formulations, a symbol differs from a sign in that it participates in the reality it symbolizes. Tillich never really got around to saying how a symbol participates in another reality but perhaps we can move a little closer to it here. If we are dealing with an order of things that does not presuppose a separate, self-contained organism inhabiting a world of distinct and separate objects but a unique energy system in constant interaction with other energy systems, then the symbolic object can be considered a condensation and a concentration of the energy of several energy systems. Then it becomes a little more intelligible to speak of a symbol participating in a reality other than itself.

Thus the symbol is inseparable from its apprehension by the worshipper. It is not a separate and distinct object but the occasion for a relation. Therefore, if the symbolic act had not changed in its nature the people who used it had; since the reality is in the whole relation, the symbol and symbolizing had become different.

These people were perfectly familiar with representational imagery that symbolized, "was," someone else; the ubiquitous emperor image took care of that. They were perfectly familiar with allegory and allegorical figures. Even the style is characteristic of standard late Roman wall decoration so in most respects there was nothing objectively new in early Christian painting. So the new relation I am postulating is no more than that, a postulate, an imaginary reconstruction that we cannot really know.

We can, however, look at a typical catacomb painting and
see what it does and how it is made.

In the first place the paintings appear in a setting that has
not appeared in this presentation before. It is not the first
example of tomb art. The decoration of graves is one of the
earliest human traditions and it appears in the high cultures
from the Egyptians to the Etruscans. Necessarily these rep-
resentations have reference to some form of afterlife, either
to nourish the dead who are felt as present in the tomb or to
extend the present world into the next or to ensure personal
survival after death. Probably all the inherited themes are
present to one degree or another in the Christian catacombs
because they were all present in the plethora of religious
movements all over Rome. It is not even to the point
whether there was anything unique in the Christian con-
tribution; these shifts in sensibility are not so easily located in
one group.

What we see, then, is a small, windowless space, usually
brightly decorated with bands of vivid color. Certain areas
are set apart for representational painting, variously divided
among the characteristic praying figure (the "orans"), typo-
logically relevant Old Testament scenes and certain New
Testament scenes. The style varies over the many decades of
the use of the catacombs but also there is much that is com-
mon among them.

Figures and scenes are both apparitions on the wall. They
do not narrate an event. Rather the crucial moment in the
event appears on the surface of the wall. There is almost
never any background, so there is no sense of setting. There
is no indication of context or furnishings other than those
indispensable to the story. Thus the space is indeterminate
and undefined. Sometimes the figures have a definite sense
of their ancient heritage in classical figure structure, but the
insistent geometry of classical Greece is almost never in evi-

dence. Therefore the empathetic somatic response that shapes the worshipper at Olympus to the cosmic order defined by the architecture is almost wholly absent.

For the most part, the style has been termed "impressionistic." This is a risky thing to do as confusion of terminology always is; impressionism is a modern term, referring to a modern mode of art, and these paintings are not modern. They bespeak another world and we can hope to know them even a little only as we know it is another world.

The term impressionism is used to refer to a style that uses short, quick strokes of the brush to suggest the impression of a scene rather than its substance. So far so good; these paintings do seem to do this. But modern impressionism is throughly within the later western stylistic experience that presupposes the continuity of space. It is an optical impression of a coherent visual phenomenon. Catacomb painting gives an impressionism of the form but, again, not the solid forms, organically coordinated, of earlier art. Rather they are figures engaged in the gesture of the symbolic act.

The effect, then, is to invoke the presence of time: the event took place in the past but the meaning of the event is now, for its symbolic function is to make the Christ present. So time, once invoked, is collapsed into the present, and the impression of act suggests the passing of time while holding it carefully before the worshipper for contemplation.

Yet the thing contemplated is not a solid form over there. It is an impression and it is of the nature of impressionism that the impression has to be reconstituted in the consciousness of the observer. The observer, therefore, does not simply receive the work passively. He must constitute it by his own participation in it. This worshipper (not simply spectator) undergoes a quite different kind of contemplation which is neither active nor passive but relational. Out of this

relation the primacy of the soul can develop, an inner life that is not identical with the public order.

At the same time, since the symbolic event is explicitly a part of the liturgy, the symbols are ways of relating the worshipper to the structures of public order. The fact that this public order had, at first, nothing to do with the state is an important part of political history. It may be that all the mystery cults had the same psychological effect of incubating an order apart from the state but the others didn't inherit the responsibility of the state as Christianity did. In any case, the inner life is no longer fending for itself without help from communal structures. Rather the symbols of deepest feeling are precisely those that incorporate the worshipper in the communal order.

This account would be complete only if we had a better sense of the actual work of the liturgy in which the paintings were embedded. Presumably, given the physical setting, there could have been actually present only the liturgy for the dead but the paintings would have been vividly present in the memory of the congregation, even if nothing like them were present in the actual rooms where the Eucharist was offered. We deal now with the psychology of the worship, not the recorded forms, and the inner response of the worshippers is forever beyond us unless it is reflected in the paintings.

These are modest works in the hierarchy of the world's art. They would hardly appear to sustain so heavy a burden of interpretation. Yet the history of consciousness does not always depend on the great public works; quality in art is a different matter. What these works have done is begin to redefine the workings of the soul.

This was the inner life of faith. It was, after all, a mystery religion, proscribed and sometimes persecuted. But it emerged into the public order. There is good reason to

think the Constantinian establishment was the worst thing ever to happen to the church; our task, however, is not to remake history but to understand it. What we are now would have been very different had it not been for the establishment.

Shortly after the establishment, Rome developed a building type that became one of the normative modes of the western mind (fig. 12). One symptom of the distinctiveness of the Christian basilica is that historians cannot trace its ancestry. It bears resemblance to this or that in the ancient world but no earlier monument can convincingly be designated the true parent. This bothers art historians a great deal, since they are dominated by the conviction that nothing is ever invented but always is caused by a preceding work. But this one really does seem to be a new form.

It is, first of all, interior. This is no small point. The ancient world knew nothing of monumental interior spaces until the Pantheon. Interiors were for the mystery of the god. People and their worship were in their world, in the light under the sky. Now the sacred is met in a spatial world that exists for the sake of sacrality. The worshipper comes apart from his ordinary world to participate the world of the sacred.

Second, it is processional. This obviously is not unprecedented since all or nearly all religions are built around the processional. But this procession is *in* the building, not to it, or around it. It is a mode of participating in the sacred space rather than simply a movement to the sacred space or object. It fuses the worshipper with a sacrality which is both in and other than the world outside.

Third, it shapes that space in a distinctive way. The great interiors are divided into geometric units in a manner linking them to the Parthenon and Olympia. These units, however, are not now defined by solid but sturdy forms; they are units of shadow divided by columns of light. Materiality

is extended to include the actuality of the least solid of all the great materials—light.

This sense of form is present not only in architecture but in sculpture as well and no clearer lesson can be found than the Arch of Constantine (fig. 13). In observing these two reliefs, it would be difficult for anyone to be so insensitive to style as not to see that we are facing two very different stylistic worlds. In fact, several reliefs of the Hadrianic period were incorporated into the later work. The beginner is likely to reach the same explanation of this curious event as that held for a long time by professional opinion; the quality of the later work is so manifestly inferior we can only conclude that the poor incompetent people pieced out their own halting efforts by stealing from other monuments.

Now, it would be hard to challenge the judgment of quality; the Constantinian work is more crudely carved, awkwardly thought out and generally duller. But the judgment of quality obscures the fact that we are dealing with two distinctly different artistic languages. There are several characteristic differences between the two works. I want to mention two, with special emphasis on one.

In the earlier work, the figures move coherently and logically in a space that is perfectly adequate for that purpose. There is no special interest in the space but it is sufficient for the enactment of the events. Not so in the later work; there space is almost nonexistent. A solid slab of stone has been cut as little as possible, just the amount necessary for the presentation of the subject; replace a small amount of the stone and the mass of the block would be restored. Yet the mass does not dominate the work as it did in Egyptian art. Rather the surface of a mass has been cut into a flickering pattern of light and shade. Thus it is, in a sense, wrong to say that there is no space. There is not, in either the classical or the modern sense, but there is something beginning that is essential to modern space—a sense of light which is a con-

dition for a sense of atmosphere. Without a sense of atmospheric space, there is no chance for the kind of personal life that is enacted as we know it.

For the moment I want to concentrate on that singular feature—the surface. Surface was distinctively important to the Egyptians; with their basic image crystalized in the geometric mass, the surface was the area where they could achieve beauty. But it was not fundamental to them. It now becomes fundamental.

By this time, the ancient world had run its course and was nearly transformed into something quite other than anything it had ever been. But what it had done and achieved was still present in the transformation and, transformed, it was not lost. Organic coherence and the continuity of drama had become surface patterns of light and dark, holding action into still contemplation. In the course of history, these things rise and then seem to disappear. But then again they are possessions of the spirit, if we will use them.

Much that is of extraordinary consequence grew from this small beginning. One of the things shared by Byzantine art and the art of the Latin west for more than a millennium was precisely the deep, passionate feeling locked inside variously defined forms of external order. Not until Giotto and Donatello was there a style that fused the inner and outer life and it may not be beside the point that in Donatello at least, the style was engendered out of a profound reflection on Greek narrative, Roman portraiture and the ecstatic energies of medieval sculpture.

In the meantime, I might only suggest that, formally speaking, Christianity was not accidental. As a historian, I had better leave aside divine providence as an explanation of the triumph of Christianity, but neither am I content to see it as an accident of individual genius in politics. Of all the religions that ran through Hellenistic Rome, Christianity was the only one able to incorporate this serious reflection into a

structure of public order that could support it without re-
ducing it to essences. Certainly there is no surviving art work
of the other cults that comes anywhere near the sugges-
tiveness even of catacomb painting.

It's a long way from Boscotrecase to Augustine, a longer
way to Donatello and Rembrandt. But in the history of
human consciousness it is a discernable way. The Bosco-
trecase painter does not stand alone. In this unfolding nar-
rative he is accompanied by the sculptors of the portraits,
the architects of the Pantheon and Tivoli, and the modest
painters of the catacombs as well as, undoubtedly, many
others whose works are lost. But he stands there honorably
in the line of our teachers and ancestors. I don't know what
a sophisticated court artist of imperial Rome, decorating ele-
gant country villas, would think of this remark. But I mean
it as a compliment when I say he is entitled to an au-
tographed edition of Augustine's *Confessions.*

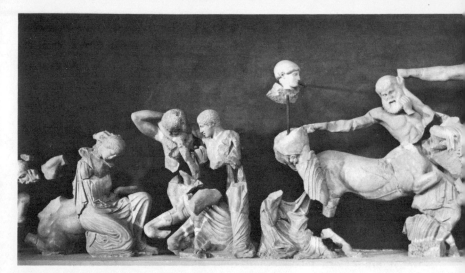

Figure 1. Temple of Zeus at Olympia, west pediment,
Battle of the Centaurs and Lapiths

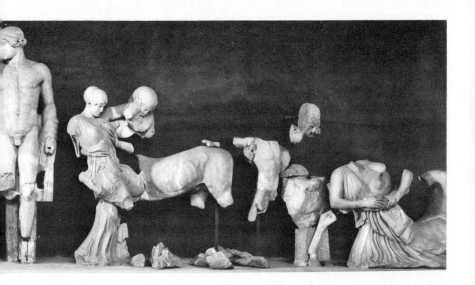

Figure 2. Lapith Youth, Detail of fig. 1

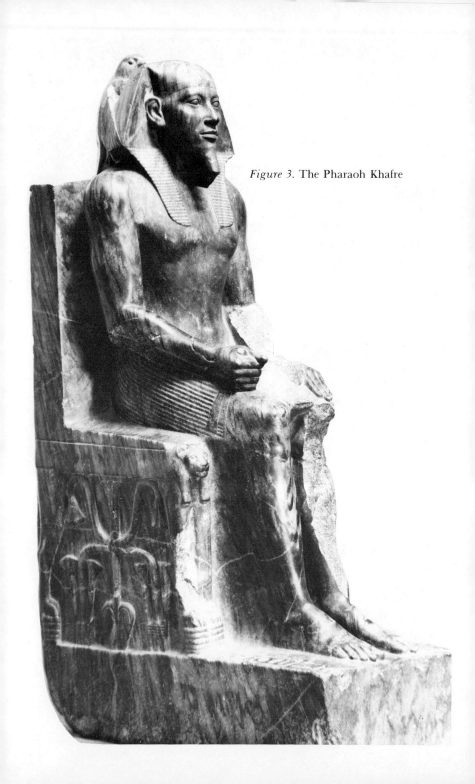

Figure 3. The Pharaoh Khafre

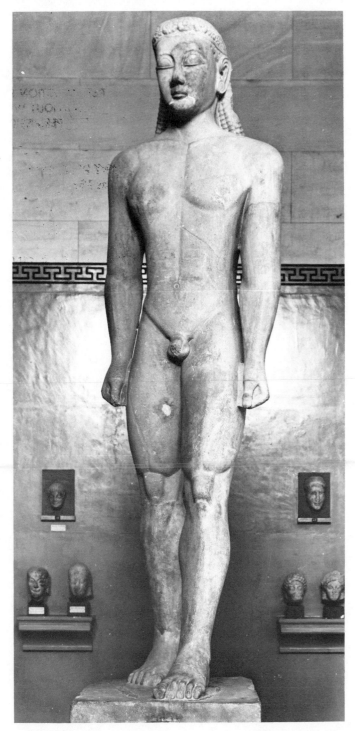

Figure 4.
Sounion
Kouros

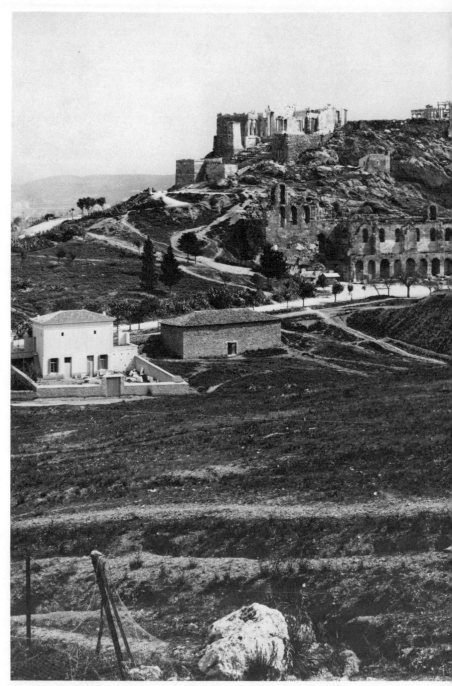

Figure 5. Athens, Acropolis

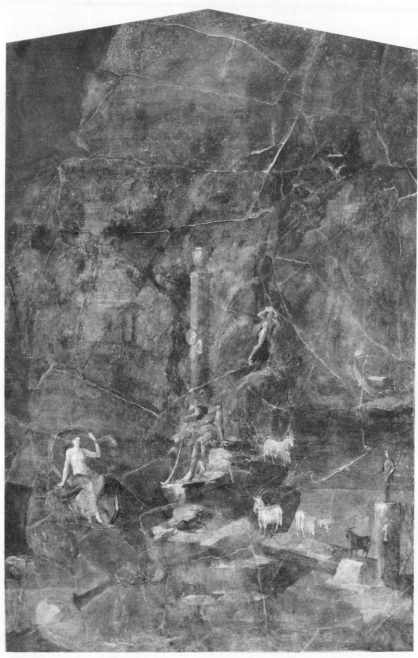

Figure 6. Wooing of Galatea, Villa of Boscotrecase

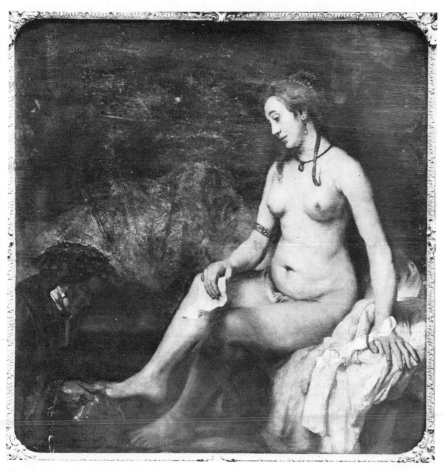

Figure 7. Rembrandt, *Bathsheba*

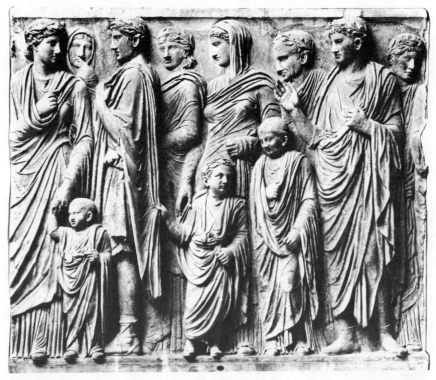

Figure 8. Ara Pacis of Augustus

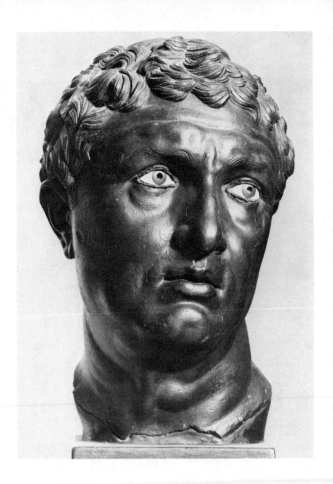

Figure 9.
Portrait head
from Delos

Figure 10. Altar of Zeus, Pergamum

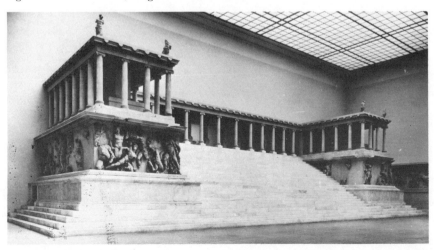

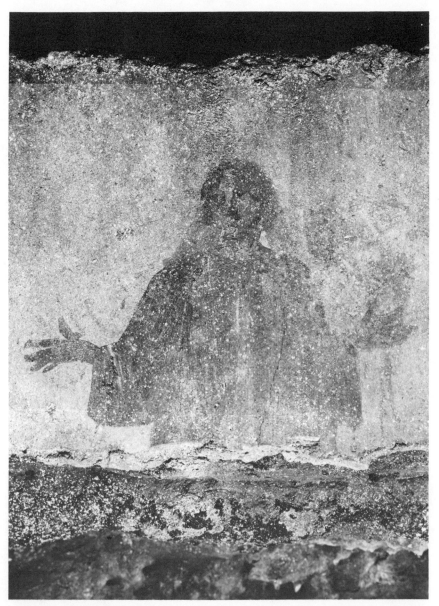

Figure 11. Orante, Catacomb of Domitilla

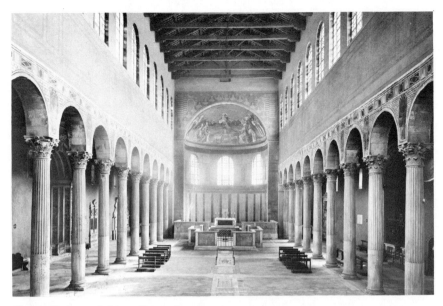

Figure 12. Santa Sabina, Rome, interior

Figure 13. Arch of Constantine, reliefs

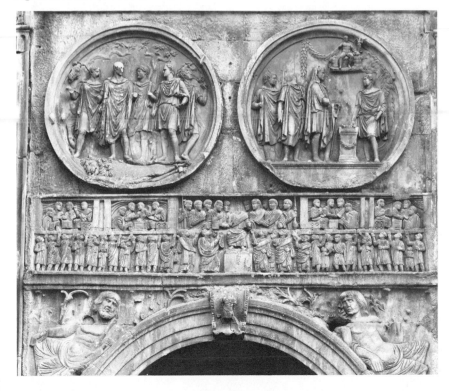

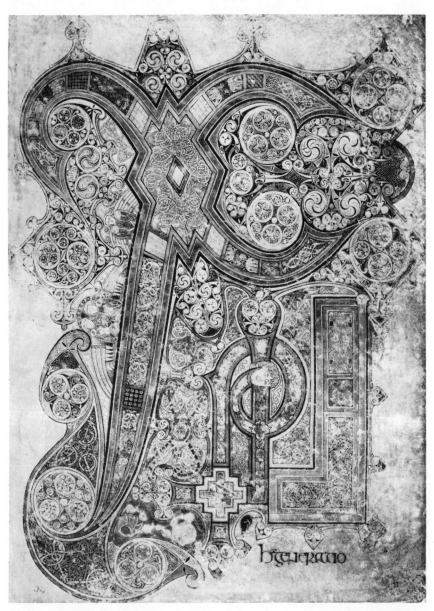

Figure 14. Book of Kells, Chi-Rho page

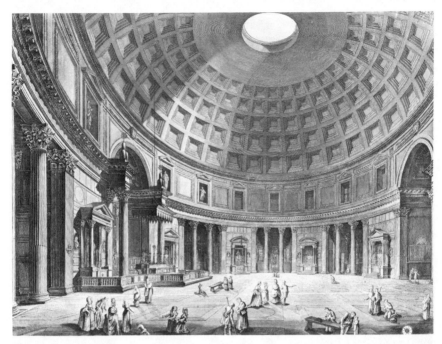

Figure 15. Pantheon

Figure 16. St. Sernin, Toulouse, apse

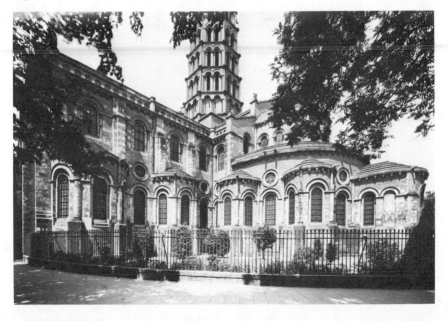

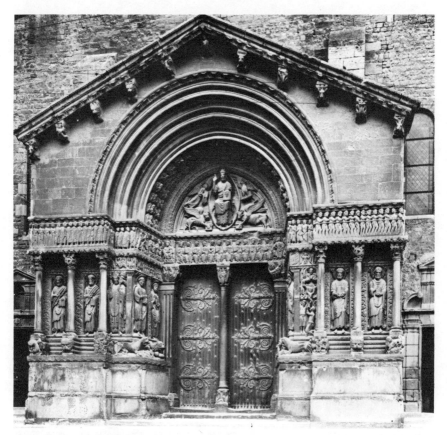

Figure 17. St. Trophime, Arles, facade

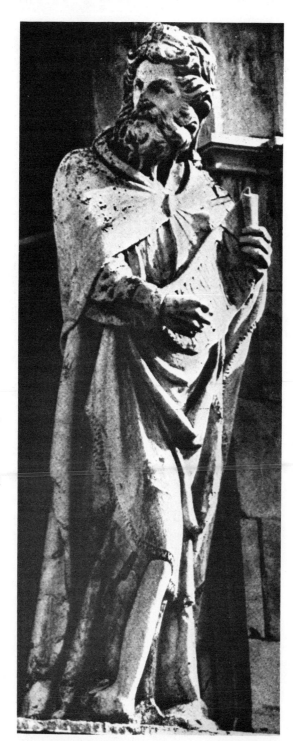

Figure 18.
Giovanni Pisano,
Isaiah, Siena Cathedral

four

THE ROOTS OF THE WESTERN IMAGINATION

Concreteness is preferable to abstraction to most of us who are not philosophers. Therefore the first chapters dealt with concrete things, with works of art in the concreteness of their structure. But my intention was not so honorable as all that. I managed to work many general principles into the discussion by way of implication and covert statement. This is not only a little unfair. It can be confusing. It is better that I should set them out directly.

What is truth? How do we know the truth? How do we know it to be true? Where is the true? Where is truth?

We speak of "the search for truth." Is truth a thing, that we should hunt for it and hope to find it? We pledge ourselves to tell the truth, the whole truth and nothing but the truth and thereby perjure ourselves beyond forgiveness for who knows the whole truth or the difference between the true and the false?

We have, for a long time, believed truth to be something that could be *said,* known in our heads. And so we have lectures and essays that are supposed to be saying the true. The essay form is reasonable and orderly and presupposes, therefore, the rationality of the speaker and the readers.

But what if we aren't rational? What then? How do we talk to each other?

I chose the traditional essay mode. And yet the essays are *saying* something that contradicts the form in which it is said. My hope is to do no less than set out a new way of thinking about the world. It is a way that uses the traditional way but it cannot be reduced to the old way. It is a new way of doing theology because theology is a traditional mode of thinking.

"I think, therefore I am," said Descartes and so we make theology into a mode of Cartesian thought. But is that the way we really live our lives?

In truth, it is not. We live in the weight and density and texture of our flesh, feeling the slow coursing of the interior of our bodies, subject to its yearnings and hungers, its passions and failures. We move in the compression of hallways, through the passages of doors, into the expansion of our rooms. Walls are weights against the eyes and trees are a screen against the sky.

This is the context of our commerce with each other. How much of what we are to each other is controlled by verbal principle? How much is shaped by place and position— above and below, next to or over against? We live with each other in the rhythms of shape and of desires that are a part of shape, of weights and textures that are inseparable from our personality, colors and odors, size and proportions.

This, and much else is the very material of our life. It is the truth of our life. It is what we live with in the world, what we think *with*. It is not just what we think about but what we think with.

For most of us these things are haphazard and disconnected, inchoate and uncontrolled. It is the mission of the poet to generate shapes of words that give order and purpose to our speech as it is the business of the musician to give order and purpose to our world of sound. It is the function of the artist to give order and human purpose to shapes

in space and thus give us forms within which we can enact our lives.

What I am presenting, therefore, are the elements of that speech, the vocabulary and grammar of a language for the setting out of truth, truth as it now might be newly understood. This language has been built up slowly through hundreds of years and, in its building up, it has made our world. Therefore, we trace it back closer to its beginnings as I tried to do in the first chapters. Now we carry it further forward, from the origins of the European idea in the wreckage of Rome and in the very different culture of the north, through its formative stage in the so-called Middle Ages. Later we can look at the great turn of the Florentine Renaissance and finally to Rembrandt. These are the makers of our own language and so we attend to them as parts of ourselves.

The issue is still the narrative as the essential matter of story. However much use art has made of story, it is not defined by the presence of story. That much is indicated already in this argument by the primacy given to architecture, the most abstract of the great arts. The final chapters will deal with the modern achievement which creates—or returns to—a true narrative art that does not use story. For better or for worse, however, art in the west since the early Greeks has concentrated heavily on story. If we are to understand ourselves we must know how our own people brought our narrative to consciousness through a distinctive use of story.

Western art did not invent the use of story. The art of every culture tells stories, even if it goes no further than portraying the characters who are known through the verbal story. But story is not full narrative, however important the story might be. Story as such sets out a succession of events in time. The simpler representations of stories do no more than describe the events as they appear externally. The

more profound story sets out in convincing formal terms the essential significance of the story; the story of the Centaurs and the Lapiths on the Temple of Zeus at Olympia is, in this sense, one of the great stories, for there are few places that so profoundly set out the fundamental purposes of a people.

In doing so, such a work makes manifest the "primal narrative" of a people; it sets out in concrete forms the basic image a people have of their relation to each other and to the world. This image, so far as art is concerned, is first of all spatial and involves relations of proportion, interval, rhythm, direction and the like. It is also dramatic and involves relations of dominance and subordination, purpose, action, personality, character and so forth. In setting out *these* things, all story is narrative.

But the narrative art born in that extraordinary period of transition from Hellenic-Roman to Christian culture is unlike any other before. It was new in two ways: it opened up the relation of the art work to the spectator and it began to show the characters in the story as having more of an inner life, the life of thought and feeling, than is needed for the story itself. What was beginning was a more complete image of the human than any seen before.

This is not necessarily a judgment of value unless you choose to make it so on grounds other than art. After all, I am told that cultivated Chinese have considered the display of the emotional life in western painting to be obscene. I think they are wrong but they have their own quite defensible case. Be that as it may, we are dealing with different worlds and different placements of the human in the order of things.

If time permitted the analysis of the great non-western arts it would be possible to demonstrate this case more fully. The Pharaoh Khafre, for example, has no inner life at all, so far as his statue is concerned (fig. 3). He is embodied office, a manifestation of the unchanging order of things. The

Great Buddha of Kamakura is a state of the soul and not a cosmic function. But he sets out a state beyond any distinctive inner life. He is the repose beyond conflict, the contemplation of the infinitely fruitful nothingness that is Nirvana. The Shiva Natarajah, Shiva Lord of the Dance, is the cosmic rhythm beyond human incident.

And so it goes. Even in non-western story—rather than sacred image—such as the immense reliefs of Borobudur, the characters act only as elements of incident. There is no indication of a moral will free to act in different ways and freely choosing the one portrayed.

What, then, of the spectator? The worshipper? All works of art presuppose a spectator, defining both the shape and the act that include both and, in doing so, make the world a people know. The range and variety of these relations is too great for any kind of summary, particularly considering that few aspects of criticism or philosophy are so poorly developed as this one. There is a reason for this omission; we have thought that the defining human act is to sit apart from the world and observe it. Therefore, our relation to all art works is considered to be that of the detached and objective scientist and we permit from the work no encroachment on this function. Some of the consequences of this attitude and the reason for its impossibility will concern me in the final chapter.

At the moment, it will have to suffice to say that most art works of significance are manifest functions. They work—to bring the deity into the presence of the worshipper, to shape the worshipper to the image of the god, or to the order of natural forces. They are parts of our world even when their role is to relate us to another world.

The last chapter chronicled the change to an art work that both opened up the world of the work to its multiplicity of implication and opened the spectator to an awareness of his own complexity. I permitted myself one brief look forward

when I pointed out that it was a long way from first-century Rome to Rembrandt's Bathsheba. It is that way we need to examine, for it is the world that produced the world we live in.

The way is not direct and it is precisely the indirectness of it that must detain us for a little. We are too often victims, in our thinking, of a philosophy of history that is not supported by what we now know. The terminology in general use reflects the problem. We all speak of "The Renaissance" without paying much attention to the reasons for the name or to the quite extraordinary idea that it is of any use to divide history into an early Golden Age, a modern revival or rebirth of that Golden Age and a middle period which is no more than middle. Even when passing time erodes any resemblance of foundation from under this evidence we have remained faithful to it. The idea of the "modern age" had some intelligibility in the sixteenth century if most of the evidence were ignored, but it has had to be stretched intolerably, period added to period, until we are now faced with the impossible task of pretending that our age is somehow a continuation and culmination of the Renaissance.

So far, this presentation has proceeded quite within the assumptions of this view of history. It presupposes a line stretching from ancient Greece to the present, a line whose continuity, interrupted by the break of the "dark ages" or the "middle ages," was preserved by the Renaissance. It acknowledges that Greece did not appear in a vacuum but owed much to the Egyptians. The ecclesiastical version of this view finds another line originating in ancient Palestine and joining with the first at the beginning of the Christian era. The continuity of the linear pattern is assumed to be the same from that point onward.

The problem with this view is that it no longer even approximately corresponds to what we know of the course and cause of history. Nevertheless we have not yet learned to in-

corporate what we most surely know into any coherent and usable pattern, so we labor on with an inherited pattern that simply no longer works.

Our most grievous error appears precisely in the period dealt with in this chapter but the problem is almost as acute back at the beginning. Greece is not fully represented by the high cult of Olympia and the Acropolis; the earth gods, the fertility cults, the mysteries all represent an equally authentic part of the Greek imagination. Their omission here is only partly justified by the inescapable fact that we have no art from those movements; what we think we know of the high cults is considerably falsified by our ignorance of the cults that were setting and context for the high cults. Both Apollo and Dionysus belong to Delphi but what little we know is of Apollo only.

Equally, when we look back to ancient Judaism we take as our spiritual ancestors the prophets and their moral fervor; we forget the altar stained with blood and smoke. It may be that not many of us who are now considering the question would seriously dispute the decision so far as we ourselves are concerned but there is little reason to take our preferences as normative for history. The blood and the smoke were not the result of a displacement of the humanity of the people who needed them. They are as much a need for people today, as much a part of our more sophisticated selves if we could only be scrupulously honest with ourselves. The religions are not matters of taste. They are analyses of the psychology of the human.

Back behind both Jew and Greek were other peoples whose work made up much of what Jew and Greek became. In truth, an enterprise such as this one becomes coterminous with human history and, whatever the justification of a selective, episodic treatment, we should never forget the fact that the episodes were embedded in a context and do not derive their primary human significance from

their place on a line that we have selected for our own purposes.

The Jews are not finally understandable without a knowledge we do not have of their Canaanite neighbors and the Mesopotamian people who preceded them. The Romans are not fully understandable without the other Italic peoples, particularly the Etruscans. And the Europeans and European Christianity are not understandable except in the context of the northern peoples who are hidden in such terms as "the Dark Ages."

It is well not to base our understanding of what a people stood for on the account of them left by their enemies. The Romans, with their ruthless domination of other people, had a vested interest in proving that those people deserved to be dominated. The truth is rather more complicated.

One obvious problem is that it is difficult to get at "the truth," particularly if our concern is to determine what the northern people contributed to the origin of the European imagination. We have a great many objects remaining from all periods. For a variety of reasons we know a good deal less than we would like of the context out of which these objects emerged. In tracing their historical role it is not always easy to determine how earlier art could affect a later art in a more sophisticated culture. Forms are not inherited through the blood, they are not parts of a particular genetic race, they are not present in the soil, except as landscapes work on the imagination of the successive peoples who occupy them. Forms are carried forward by being seen, by shaping the formal imagination of the people who participate in them, and it is not always easy to trace the connections. This is particularly true of very early art, the art of non-literate people. There should be no doubt that those forms enter into the shaping of our imagination but it is a case to enter on with care if it is to be handled responsibly.

What we cannot permit ourselves to do is accept and live

within the implications of a terminology such as "primitive," "barbarian," "the Dark Ages." No doubt the period of the "early Middle Ages" seemed dark to those who belonged to the classical heritage but there were a great many people for whom the time was not dark at all. It is not a matter of romanticizing primitive people after much of current fashion; few of those who write and read such books as these are likely to think the Celts contributed as much to the human enterprise as the Greeks. But neither is it a matter of sentimentalizing the classical world. It is said to imagine the ruined cities and burning villas of Roman Gaul and Britain but those cities and villas were built because of the slaughter of thousands on thousands of people and the near obliteration of cultures that could have developed richly and creatively. "Darkness" is a function of who is using the term.

It is not so simple a matter as depriving ourselves of the many pleasures of the non-classical cultures. Those cultures have entered into our own culture in the deepest possible way. Because they have helped shape our forms they have helped shape our psyches or they shaped the psyches of those who made the forms that have shaped us. The problem is that, in Freudian terms, the dominant classical heritage has acted as a super-ego and repressed the Celtic-Germanic heritage into our sub-conscious where it wreaks the kind of horror in our imaginative life that unconscious, undisciplined imaginative powers always do.

It is necessary for us to make something like an inventory of the forms of our imagination, including those that cannot be examined at great length.

1. Chronologically, the earliest forms we have looked at were the rationalized mass and the geometric space of Egyptian art. This is not, however, the only system of forms that lay the other side of the Greeks. The Mesopotamian people developed a singular combination of heavy masses not rationalized by a geometric order and a ferocity of energy mani-

fested on the surface. Much of Mesopotamian art is an art of power as Egyptian is an art of systematic order. This powerful energy informed the intense moral personalities that are the greatest contribution of the ancient Jews to the process of forming.

2. The organic energies and articulations of the body used as the primary instrument for the interpretation of fundamental stories and the placement of the human in the order of mythical space.

3. The organic body and a controlled space used both to set out and to evoke the inner life.

4. The detailed reproduction of the appearance of the face in Roman portraiture with more than occasionally a suggestion of the private emotional experience behind that face.

But the roots of the imagination go deeper than the Egyptians and the Mesopotamians. We are not other than our prehistoric ancestors; they are a part of our very selves. Thus:

5. The womb-like caves of Paleolithic man with the paintings of the great animals. We do not know the rituals enacted in these cases, except that they almost certainly involved the wandering search into the earth, the hunt and the ritual killing. But in no other art has the vital energy of the animal been placed so surely on a surface that could be seen.

6. The great stones, the megaliths, which appear in the west of Europe from England to Malta. We mostly can't know why these stones were set up or how they were used. We can only know what they are, which is a distinctive dimension of the imagination.

7. The abstract ornament of Neolithic man, probably the ancestor of the Celtic interlace and certainly another distinct disposition toward the universe.

These, then, are the elements of the European imagination, a psychic vocabulary which entered the visual speech of

people who thought of themselves with a different heritage. The issue is not quality—"art"—which is a different problem. The list does indeed contain (or at least leave room for) works of the highest quality, but an inventory of linguistic elements is not necessarily determined by quality. These are the forms of thought, the shapes into which the gods are formed, the elements of which "art" is made.

The first four of the list are Mediterranean. The seventh is quite general. Only the fifth and the sixth are parts of the territory that was to become Europe and both belong to the very ancient past, ancient even to the Romans. The question now is the nature of the formal language and achievements out of which the coherence of Europe arose. This means primarily the Celts.

There were many peoples in Europe both within and without the control of Rome. Whether they can with reason all be called by that inexact term "Celt" is impossible to say. They were not a bookish people and bookish people like ourselves, who tend to identify civilization with books, are inclined to let the absence of books justify what the Romans did to these people (although in all fairness it must be said that they made some effort to do it to the Romans first). The writing of books is in itself a disposition toward the cosmos that has been productive of most of what we now think of as human good but that good is bought with a price. The Book is the repository of truth and draws attention to itself. The Celts, a bardic people, had no such disposition toward permanence. For them the narrative was inseparable from the hero moving in his wanderings among the ever-changing powers of the earth—the streams and springs, the animals, the sacred well, the horned god, the triple goddess. Above all his world was a world of change and transformation, lacking the clear cut distinctions and separations of the Mediterranean world. There is no Celtic Aristotle to expound and

teach us Celtic logic, but the Celts did have a logic. It is a logic we need.

In order to see the visual embodiments of that logic, the choice is not large. The Celts moved and their art is mostly ornamental metal work used by the warriors or in sacrificial ritual. It is work of high quality but relatively slight and, in any case, my concern is not only with the Celts but with the forming of Europe. For this we had best look at the last great flowering of the Celtic imagination in the Irish manuscript illumination of the eighth and ninth centuries (fig. 14). The Roman Christian Church had brought, in the monastic movement, an institutional structure that could absorb Celtic artistry into a more established form. The book itself gave occasion to story and to abstraction. The occasion was propitious.

It would be well if we meditated on this art, meditated as we do on Greek forms. Greece is part of the intellectual equipment of all educated people. It is a circular argument: if they have not meditated seriously on the Greek idea they aren't educated people. We should be as rigorous and as demanding on Celtic art; he who has not meditated as deeply on the Lindisfarne Gospels or the Book of Kells has no grasp of the psychic essentials of the western mind.

What these works meant for those who made them, those who saw them is further from us than the Parthenon twelve hundred years earlier. What they mean to us is certainly not what they meant when they were made but what they mean to us is all we have to go on. (This actually differs only in degree from our relation to all works of art. Even so we bring one advantage to the situation. We are not the people who made the works or used them and so we are better equipped than they are to see the things they took for granted, which are among the most important aspects of the works.)

What we 'see (the first person pronoun is obviously required here but it is part of scholarship to assume that what I see everyone ought to see), what we see is quite unlike any other form of art.

Inevitably when we look at such a manuscript as the Book of Kells the first thing that will impress us is the sheer sumptuousness of it. There is every reason to think this intended. The Word is not simple discourse. It contains the sacred power. It is itself a conjuration against the powers of darkness, a meeting place for the holy. It can, therefore, be presented properly in the ritual only in the richest and most sumptuous form possible.

Whatever we may think of the devices they used they are teaching us something about words that is true.

What we see next depends on training. People trained in criticism are likely to see the remarkable composition. Others are likely to see the labyrinthine net of coiling lines. They may be closer to the symbolic heart of the style.

The Celtic interlace is a very early motif in pagan Celtic art and equally dominant in Christian Celtic art. It is the most decisive contribution of the Celts to significant human thought.

The interlace begins nowhere and ends nowhere, or, perhaps better put, its end is in its beginning. Sometimes this is quite literally true; all evidence of a joining is obliterated and there is no pause in the eternal return. In other cases the ribbon of the interlace ends in the head of a snake or a bird. This head will bite the other end of the interlace or across the ribbon-body of an adjacent creature so the mind is led through an intricate network of continuity, transformation and interchange. All is movement, metamorphosis, exchange.

Dominating some plates (Celtic logic is not single-minded) or at rhythmic intervals throughout the interlace or on the borders of the figured plates, are the intricate forms, circles

containing circles containing swastika-like scrolls, all in cease-less movement. All is energy.

Yet there is present in nearly every plate, and absolutely dominant in many, rigorously rectilinear forms. The energy is framed and therefore contained within the fixed and unchanging shape of rectangles.

This is quite consistent with Celtic logic; the world is com-plete and there is stillness and fixity as well as movement and transformation. This principle carries over into the page compositions. The great Chi-Rho page is one of the remark-able asymmetric compositions in art, the center and axes of the composition syncopated against the center and axes of the pages, the great energy of the letter sweeping outward to the four corners. Other pages are symmetrical with the ut-most rigor.

It would be difficult to find, prior to the twentieth century, a more purely surface art. Beside this even a Byzantine mo-saic looks thick. It is an art of pure line and line belongs to the surface. *All* is surface. There is no mass or weight.

Yet it is not quite true to say there is no space. The line as interlace is infinity, itself a transcendence. The interlace is a screen, a delicate, rhythmic, flowing screen. A screen is be-tween us—and the infinite emptiness, the empty infinity beyond.

The screen is not static, for the line is not static. The line is ceaseless movement, ever returning on itself, the infinity of the sea which is endless motion and endless expanse against the infinity of the sky which is endless motion and expanse opening to the infinity beyond that.

It is impossible to say how such works affected those who made them and saw them; our responses are a faint clue if we open ourselves to the work and do not compel it to serve our own prejudices. Under such conditions, I would say that these works are both condensations of and evocations of a singular and distinctive psychic state.

Of course, all works of art express and evoke a psychic state but there are many and varied types of involvement and degrees of intensity of that involvement of the spectator with the work. Some works are so constructed that they emphasize the differences and the separation between the spectator and the work. These paintings, or drawings, however, are traps for meditation. They cannot rightly be seen apart from the gospel they precede and accompany; they must be imagined as a kind of visual commentary in a way we can barely experience. It may be that there was a closer psychic link between text and ornament than we can feel, who see them mainly in reproduction, wholly apart from the text. But the motif of the linear screen appears only very late in the Christian context. Earlier it appears mainly in isolation from any such setting. As a part of the language of the imagination it is sui generis.

What it does is, by its energy, take the imagination out of the ordinary world into a world of pure and unspecified energy, of miraculous change and transformation. There is never rest or specification so the psyche can only be aware of its own fears, its own ecstasy in a world wholly outside anything it consciously knows.

These works force us to ask a question that has not risen before in this study. What religion do these works belong to? So distinguished an authority as Carl Nordenfalk has this to say:

> It is an almost inhuman art, so ruthless in its stylization, rooted in the tribal past and traversed with savage accents; utterly opposed, in short, to all that Christianity stood for. Nevertheless, by a strange paradox, this heathen art served the cause of the new religion and, in fact went far to body forth the sanctity and transcendence of the Word of God. It was in its magical suggestions that illumination found the common denominator enabling the metamorphosis of pagan art into Christian.[1]

This is a position to take seriously. But it somewhat over-simplifies the nature of religion. Only persons are Christians. Styles aren't. It is well known that people who are, with some degree of compulsion, converted to another religion carry over the old gods under new names; Mexican village saints are often Aztec gods with Christian names.

But all people must speak the language they know even when—what we and not they are in a position to know—the language imposes its interpretive logic on what is said. Celtic Christians were still Celts speaking the Celtic formal language. And that language enabled them to say things that the Mediterranean language could not.

The formal language of Greece and Rome was a language of clear distinctions, of a union of parts into an intelligible organic whole. I cannot, obviously, say what the Christianity is that Professor Nordenfalk considers but I am supposing that Hellenic intelligibility is part of it. Christianity, however, is not a Hellenic religion and is not exhausted in those great forms. The very different Celtic principle was a fitting form to receive the Christian idea.

The form is, indeed, wholly different, almost as though it were a deliberate contrast, a destruction of classical forms. Instead of the discrete and the intelligible, there is the infinite, the unrestricted, the changing. Instead of the organic wholeness, there is inorganic detail. Instead of the three-dimensional body, there is the flat surface covered with the net of the interlace. Instead of organic continuity there is division into sharply distinct compartments.

Instead of story there is only abstraction; the few stories in the manuscript are reduced to pattern. Yet there is a narrative, for the page is a model of the journey and its dangers, of order against the immense infinity and it itself becomes part of the means to the end, for it is magic. It is a concentration of energy and order against the evil beyond.

Our ancient infatuation with the Mediterranean has obscured the extent to which the Celtic interlace entered the western imagination. It is found on the doors of Romanesque churches, in the window tracing of Gothic cathedrals. Firmly joined with the three-dimensional body it is still a basic motif of Dürer's great etchings. Driven out by the modeled bodies of the Italian Renaissance, it was there in the sub-conscious to emerge once again in the twentieth century in the painting of Jackson Pollock. .

At the beginning what it needed to become established in the western imagination was a place to happen. The interlace was not found only in books; it was a dominant motif on the famous Irish crosses, on liturgical objects and presumably on many things long lost. But to be established in the processing spirit of the culture it required architecture. This happened with the birth of the Romanesque.

Architecture is the original source and support of the arts. As is usual, the building is primary and the other arts cluster around it. When the basic building type matured, western culture had begun its work. I do not know—or care—where causality lies.

There is one more Roman contribution—the Pantheon (fig. 15). It has been called, rightly, the first great monumental interior space. It is not truly the first; it was preceded by the Paleolithic cave cults, the megalithic temples of Malta and the cult buildings for the mystery religions. But it was the first monumental interior space built by a high culture. The Pantheon has been called, again rightly, "the first mosque," for it led, by way of the Byzantine churches, to the great Ottoman mosques.

We know nothing of how the Pantheon was used but it prepared the imagination for interior space while Roman construction provided the model for the round arch. The church itself required interior space, for it was a congregation acting in consort and the building was an edge around

the community, not the habitation of the god. So the medieval church was born.

The Romanesque church is not Roman but purely European. Beyond the round arch it owes very little to the Romans. As European it is not only later but far more extensive than Irish manuscripts. It is certainly not causally related to Irish art and its formal ancestors are many. But the peculiarly Irish character of interlace was a specific instance of the generally Germanic style that was widespread in Europe and which found its final location in the Romanesque church, thus contributing to the founding of the European soul.

The pure Romanesque church is a singular, almost unmistakable form (fig. 16). It is a series of cubic masses, multiple not single, mounting upward in a complex rhythm so that the axes of the separate forms make a complex interior network. Often and increasingly, the surface of the mass is articulated by elaborate ornament that commonly is the Celtic interlace or a pattern of sufficient complexity to function the same way.

It is a mass, but a penetrated mass. Clearly defined openings are present in all parts of the building. Doorways are a study in themselves. They are, generally speaking, a prime imaginative form in our psychic life and specifically a fundamental form in the language of art. They are, as entry, the transition between our world and another. The Greek temple occupies the same space as the worshipper; the Christian church is a space set apart and the doorway is a basic theological principle, for it connects two worlds.

In penetrating the masses of the building the door reveals the masses as hollow and the surfaces as boundaries around that hollow. These walls, for all their mass, are screens between two worlds. Technology dictated the mass, for only a heavy wall could support the vault. The social order required it; Durham Cathedral was described as "half

church of God, half castle 'gainst the Scot." But the imagina-
tive order required it too, for the people came apart from
the dreadful dangers of the world beyond into the shelter of
the Holy City.

This, then, was the screen wall on which the sculpture
emerged (fig. 17). The geometry of the sculpture is less the
geometry of a single block of stone than it is the thick sur-
face of the screen; the sculptures are locked into the surface
as masses or as themselves the interlace. The energies of the
body are never articulated organically but in an ecstasy or
solemnity of feeling articulated across the surfaces of the
mass. They never quite change into animals but they are in
the presence of the terrible beasts who are compressed into
the column or, in all their terrible power, subdued to guard-
ian figures at the door.

But it is only superficially that Romanesque sculpture can
be reduced to types. The Christ figures vary from the grim
and terrible judge to the ecstatic Lord of the Revelation to
the gracious and benign Redeemer. Below the terrible judge
of Moissac, the apostle zig-zags in his ecstasy and energy. At
Chartres, the kings are benignly present along the lines of
the building.

These are not yet persons, although, strikingly, they
possess individuality of feature. But they are states of the
soul and every true Romanesque church sets out a different
mode of the soul; so, across Europe, there are displayed so
many of the possibilities of the human psyche that Roman-
esque art can be experienced as a living museum of human
possibility.

Romanesque is usually thought of as continuous with
Gothic. It is not; in many ways there is a sharper psychic
break between Romanesque and Gothic than there is be-
tween Gothic and Renaissance. The Romanesque was the
time when the great themes of European Christianity were

first set out in a form that could be used by those who followed.

Thus Romanesque art is one of the founding myths of western culture. It is particularly important to recover the sense of it for it is the last of our styles to have held conscious possession of both the Mediterranean and the Celtic heritage of the west. It is, therefore, a symbolic necessity, for it set out coherently the basic symbolic archetypes—door, wall, animal, interlace.

five

WESTERN SPACES AND THE SOUL'S NARRATIVE

Every mode of presentation has its own rhetorical advantages. One advantage of the lecture form is its ability to present two things at the same time; a picture can be shown on the screen while the lecturer is speaking of something else, with the two things syncopated against each other.

Translating a lecture onto the printed page makes possible different devices but effectively forecloses that one. This is unfortunate for that device was used, in the lecture version of this chapter, to make a point which will now have to be made verbally.

During a lengthy preamble, two slides were held on the screen, one showing the Isaiah of Giovanni Pisano (fig. 18), the other the St. Mark of Donatello (fig. 19). They need to be looked at, without analytical explanation or interpretation, for they dramatize a problem of singular importance in our understanding of our own historical past.

Both are very great works of art, among the greatest our culture has produced. They are worth looking at for that reason alone. But also they exemplify one of the crucial problems in historical interpretation, one of the assumptions of our professional work that completely block the kind of understanding I am trying to establish.

Giovanni Pisano's Isaiah was done in the latter part of the thirteenth century for the facade of the Cathedral of Siena; Donatello's St. Mark was done in the second decade of the fifteenth century for the church of Or San Michele in Florence.

Both chronologically and stylistically, Giovanni Pisano's work is pure "Gothic." Equally, Donatello's work is "Renaissance." In fact, it can with justice be called the first full Renaissance statue, the first true Renaissance work of art.

This is quite true and the truth of it will have to concern me a little later. But later, for there is other work to do now.

Our historical study has busied itself with such distinctions, without paying very much attention to the reasons for making them. Part of the price of this schematizing of history has been the kind of distinction these works represent. There is no way at all of comparing the quality or value of these two statues. Each is artistically great and humanly profound. Yet Donatello's is known and honored widely. Giovanni's is known primarily to the student of Italian sculpture. Donatello's is Renaissance and so is a part of the process that has led to the modern world and to us. Giovanni's is Gothic and provincial Gothic at that and so has little to do with us. The scholar will be aware of the immense debt Donatello owed to Giovanni but, even so, Donatello is on our side of the gulf between the medieval and modern worlds.

I am proposing, on the contrary, that the very real differences are not so important as the common enterprise they both contribute to, however differently. I am proposing that the western enterprise must be seen as a continuous whole whose main problems were set down very early and, in a succession of dramatic transformations, have made our world right down to today. In principle, this does not differ from the development of any and every culture. The only real difference is an immensely practical one: that the western tradi-

tion has a greater variety of elements than any other. This is a difference of great consequence.

In the last chapter I proposed an inventory of these elements that make up the vocabulary of the western imagination. It might be useful at this point to summarize those analytical principles that are particularly appropriate to the understanding of what is happening in Giovanni Pisano and Donatello.

Chronologically, what we saw first was the intensely concentrated mass of Egyptian art. This mass is not, however, simply inert weight but it has been penetrated by human intelligence: it was thought out in terms of its six bounding surfaces and the three axes which are felt, not seen, but are nonetheless real. Human energy was crystallized into this spiritualized mass.

Greek art considerably complicated the situation. From an early time the Greeks felt the independently acting human body to be a prime symbol in the human experience. Yet their formal language began with the shaped mass of stone, partly because that is the nature of working with stone, partly because they knew the Egyptians well and inherited the Egyptian formal language.

The result was an extraordinarily fruitful tension and interaction between the abstract mass and the organic energies of the body. Initially the geometry of the mass clearly dominated the statue and the organicity of the body strained against it. Gradually the balance shifted until they reached the splendid moment of balance that marks the fifth century. The balance shifted still further until the organic was the dominant impression given by the work. But even in the most anecdotal of the late Greek sculptures the geometric inner structure remained the core of the work.

It is both important and necessary to note that there is no room in the enterprise for the individual quirkiness of a particular personality. The formal life of a Greek sculpture is

worked out in the tension between geometry and organic energy. These provide the imaginative energy of Greek architecture. When organic vitality was linked with a mythical subject it could not present the wholeness of a living individual but rather the great, elemental types of human drama and morality.

The transition had already begun in Hellenistic Greece and was continued distinctively by the Romans. I tried to suggest in one small example how the objective structure of Greek art—the work as a part of public order, designed to incorporate the person into that order—began to shift to a more private structure that had its effect on the private inner life of the spectator.

This first glimmering of the artistic treatment of the inner life developed in several ways. One would take us apart from the chosen line of this book—the art of Eastern Orthodox Christianity. Byzantine art is preeminently an art of surfaces, of richly colored surfaces, shimmering with light. Thereby the present world is transformed into the transcendent world. It was an art of the liturgy, joining with the words and the actions of the liturgy itself to make the Holy City which the worshipper entered.

In western Europe this delicate awareness of the inner life came to an abrupt halt with the end of Rome's influence and the shift of authority northward. But the Celtic imagination was able to cope with things wholly out of range of the classical imagination—the "inner life," as it were, of the world, all those forces and energies that earlier peoples attributed to the life of something very much like themselves. What there is in the natural order to inspire this reaction we cannot really say; until we know better what it is we should not abandon too quickly one of our formal instruments for dealing with it.

The intense surface was displaced to the surface of heavy walls. The figure returned but as a congestion on the sur-

face, not a form with any touch of inner life. Life was seen as power against power.

The walls condense onto ribs and columns. The weight is concentrated, the masonry is congested into lines. The way is prepared for the Gothic. Within the real limitations of art historical methodology, there is, indeed, such a thing as a Gothic style. The cubic masses of the Romanesque are transformed into an articulated skeleton, the distinct compartments of the interior fuse into a single unified space, the solidity of the walls dissolves into a membrane of glass (fig. 20). The error comes only in taking these points of stylistic evolution as decisive for the development of the psyche. Within the transmutation of style, the consistent formal vision is working itself out. The wild variety of Romanesque typology is brought under the discipline of a more controlled formal intelligence, but the same basic principle is at work: a multidimensional interior space articulated around the pilgrimage way from doorway to altar to the holy region above. Instead of the grim protection against a world of terrors outside, the walls are now delicate screens that flood the interior with light; not light in quantity as the glass is too dark for that, but an intensification and glorification of that quintessence of light, which is color.

The new serenity spreads to the sculpture which is still clustered primarily around the great doorways (fig. 21). There is no longer the sense of fearful anguish that makes the Romanesque facade so powerful a barrier between exterior and interior. Rather exterior and interior flow together; the interior is still the Holy City—but not so different now from the outer world which is the place of the evangel radiant with heavenly light. The sacred persons are no longer fierce guardians, or magic emblems; they stand in majestic serenity, each in the uniqueness of his bodily form. There is not yet a sense of personhood, for each calm face partici-

pates in the redemptive calm of the Christ figure in the center, but each stands as a clearly defined individual.

The fundamental geometric principle remains the same. An elaborate linear network made partly of architectural forms, partly of sculpture, defines the interior space. There ensued one of those rare and precious moments of perfect balance, when all the elements fit into a single harmonious whole. Such moments are always short-lived. The elements, which had been separately defined in the earlier period, then fused, now begin to reemerge separately. The linear screen increasingly dominates the architecture. The figures emerge from the vertical frame, move, act across the lines of the architecture, begin to take on a separate existence. The way is made ready for Donatello.

First, Giotto and Giovanni Pisano.

Giotto is one of the truly decisive figures in the development of the western mind. He is decisive in certain of his formal innovations but even more important to us is his development of the means to set out both inner emotion and outer involvement. Giotto is, above all, one of the supremely great story tellers, but above even that is his ability to link the story to the narrative in the profoundest sense.

Analysis of the nuances of Giotto's work is the work of a lifetime; almost any one will provide an example of the essential workings of his style. His version of the "Noli Mi Tangere" (fig. 23) is a particularly subtle example. Mary reaches yearningly toward Jesus, who steps away. He gestures toward her, to ward her off—"Do not touch me"—but the repelling hand also assumes the form of a blessing as he looks down at her with tender love.

The vocabulary is quite new, for the simple reason that there is no precedent in the history of art for what is going on here. The formal language is at the service of a dramatic relation and interaction. The human body is the instrument

for the revelation of inner emotions, feeling, desires. This is a sample, although a first rate one, of one of the most subtle, wide-ranging investigations into human psychology ever achieved by a human being.

The "Presentation in the Temple" (fig. 22) is not simply light relief in a fairly solemn presentation. It is indeed that, for it is one of the few genuinely witty paintings in great art. The Christ child, held by the aged Simeon, reaches for his eager mother in the ageless gesture of a baby held by a stranger. But curiosity vies with fear and his eyes turn back to this strange old man. The grasp of human feeling is as precise as it is in the other.

But more is going on. There is a deep pathos at work. On the left, the child and the mother are clearly in front of the baldachino. On the right Simeon just as clearly holds the baby under the baldachino, which is to say above the altar. This very human baby is, from the beginning, the eternal sacrifice for the redemption of mankind.

Thus Giotto's language of the body lends itself to the exposition of the subtle interplay between ordinary human life and theological proclamation in a manner which shows doctrinal formulation as an extraordinarily clumsy instrument, wholly lacking in existential depth. At a time when the claim for the final authority of doctrinal formulation was intensely pressed, Giotto was transforming art into a remarkable evangelical instrument quite apart from doctrine. The human body itself became the prime instrument of the extraordinary visual logic. The authority of the bodily movement is such that the bodies of the spectators, surrounded by the central events of the faith, participate empathetically in those events and by their own reenactment of the events become, in a real sense, part of the body of Christ. There is nothing like it anywhere else in art, because there is nothing quite like the Christian analysis of the divine–human situation. The acts of God are made manifest in human flesh.

The human body is the incarnation of the sacred acts and the revelation of divine truth. Human life in its ordinariness—the comic reactions of a baby—is inseparable from the sacred revelation, no, is itself a part of the revelation.

Other arts, in fact almost all serious and developed styles, have a way of dealing with the ordinary. But never in the context of the sacred or as an instrument of the sacred.

It is right to focus on Giotto's dramatic language for that is the uniqueness of his style. But this must not distract from the preoccupation with form, which is the leading concern of these presentations. Giotto's paintings are still very much part of the surface of the wall. He needs the block-like mass of the figure in order for it to move with the appropriate authority, but he strictly limits the depth of space so that the painting will not offend the integrity of the wall. In art historical terms, the respect for the wall as well as for the subject matter program is purely medieval, just as the expressive gesture of the bodies acting in moral purpose within a distinctly constructed space is pure Renaissance. In other words, the terms Gothic and Renaissance make no sense at all when applied to Giotto and grievously obscure the important development in the language of the imagination.

Because they act on the wall the figures themselves must respect the integrity of the wall. They are massive, block-like forms moving with stately and disciplined determination. There is no anatomical articulation at all, no organism within the garments, no bones under the flesh. They are pure expressive action, shaped and disciplined by the geometry of the wall.

With Giotto, the title of this chapter may become clearer. I would not go so far as to say that either Giotto's work or the sculptures of Olympia mark anything like "the birth of the soul," which would be to make a mockery of a major part of other human effort. The word "soul" is to be understood as

the full self-awareness of the human organism responsive to its tragic contradiction, capable of moral response and thereby able to survive the dissolution of the natural body which is the appointed fate of all organisms, including the human. There have been souls formed beyond the possibility of numbering throughout human history, else the principle of the divine logos working in creation from the beginning, the cosmic Christ, would be a blasphemy and a presumption. The single merit and the single task of Christendom has been to affirm the principle, to understand it, to develop the processes for the forming of the soul, a task so often evaded and denied in the development of the imperial church.

Thus the process that has been, in its own way, adumbrated in the work of all the cultures and incarnated in the gospels reaches a crucial stage with Giotto, who demonstrates the possibilities of the wholeness of human experience in the matter of the earth.

But no man, not even Giotto, does all, and his great but lesser-known contemporary, Giovanni Pisano, had his own work to do (fig. 18). For Giotto, bodily action was under humane discipline. The emotional characteristic of Giotto's style is restraint and dignity, so it is not a language for deep exploration of human passions. With Giovanni, the body is a concentration of energy. It is not the expressive geometry of Moissac or Souillac; it is too coherently human for that. It is, rather, the expressive energies of the stone projected from the architecture rather than confined within its surface. Even gentle events become for Giovanni a coagulation of passionate energy.

The body in Giovanni's sculpture is organized around its function in the event but it is not merely a translation into material of the specific implications of the event. He is less concerned than Giotto with specific moral issues, more concerned with the translation of the shape of stone into human

energy. He is one of the most intensely sculptural of all sculptors and it is not surprising that one of the best books on Giovanni was written by the greatest twentieth-century sculptor, Henry Moore.

With this preparation we can turn now to Donatello. It is not an easy thing to chronicle the forming of a great artist. It is easier with Donatello than with most. There were major works by Giotto in Florence. Giovanni Pisano's greatest works were in Pistoia, Siena and Pisa, all nearby cities. There were many ancient remains available for study—Roman portraits, Greek gems and pottery, sarcophagi. The ideas of French Gothic sculpture were available in small ivory figures. He was, therefore, under instruction from the major elements of the western tradition.

· The result was his St. Mark (fig. 19). This long discussion has been useful, partly to show the immense diversity of the western vocabulary and visual logic, partly because it is necessary to emphasize continuity against isolated periods. Donatello is demonstrably in the tradition that had been developing for centuries. This figure is acting in the integrity of his spirit, within the axial structure of the stone block, resonating against the surface of the cubic mass of the building. There is something new. For the first time in western art, a represented figure acts with coherent, anatomical organization. The effect of this was electrifying. It meant a new way of making art, it opened up seemingly infinite possibilities. So invigorating was it that writers of a few generations later began to speak of it as a "rebirth." To some it was a rebirth of the ancients, and they succeeded in fastening that old-man-of-the-sea on our backs. To some, more accurately, it was simply rebirth.

There is no precedent in art for this articulated organism except in ancient art. Equally there is no question that Donatello learned from the ancients how to do it in stone. But this is not even approximately a Greek or Roman statue. A clas-

sical statue simply *is,* completely self-contained. Even its ac-
tion is a manifestation of being and is restrained within the
figure. However quietly, this figure *acts,* his purpose is not in
being but in relation.

Michelangelo said of this figure, "It is the finest picture of
an honest man I know of," and further, "If I knew the apos-
tle looked like this I would believe his every word for such a
man is incapable of telling a lie." Michelangelo had a gift for
words and an extraordinary eye for artistic essentials. He
was aware that the essence of this statue lies in its pro-
foundly moral relations. Although Michelangelo rightly em-
phasized the virtue set out in this figure, "moral" does not
refer simply to goodness but to the capacity for human
beings to act by choice and with purpose in the conflicts of
human experience.

There is no single feature of this work that is without
precedent. What is distinctive, unique, revolutionary even, is
the fusion of these features into a new unity. For the first
time we have an image of man in the completeness of his ex-
perience. Exaggerated, yes. Donatello was Italian and, there-
fore, Mediterranean; he draws on the art of the classical
body in mass and knows little of the Celtic-northern in-
terlace. If he knew everything there was to know about the
completeness of the human there would have been no work
for his successors to do. Furthermore, there is a wide range
of quite genuine human possibility set out in the work of the
non-western cultures and if we are to have any sense at all of
the completeness of the human we must learn how to know
and use that work properly.

There was, indeed, an extraordinary range to Donatello's
work. We see in the Mark a quiet, restrained dignity that is
close to Giotto. A few years later he did his famous Zuccone,
infused with the passionate energy of Giovanni Pisano. We
do not know the identification. It is certainly not Amos but
equally certainly it is my personal image of Amos. Donatello

could equally well set out the warrior saint, the general, a gentle unworldly saint, the Mary Magdalene embodying the ravages of repentance, St. Guistina, a quintessence of feminine grace and sensuality, and many more. His narrative reliefs are a profound analysis of the moral implications of dramatic situations. Thus the other part of my title comes to a fullness of realization. The "soul" is the capacity of a person to act with purpose within the understanding of a situation. Such a dramatically defined situation is a relation, not simply existence. The narrative is enacted among full persons. The event may be evil or futile or tragic; that is not the point. The figures are in relation. Very nearly every work by Donatello, and an overwhelming majority of works after him, presuppose a dramatic relation.

The primary relation is, necessarily, within the story. But the changes in figure structure presuppose, too, a change in the relation to the spectator. The other major addition, the one most histories treat as the principal revolution of the Renaissance, was the invention of linear perspective. Again, this is to be associated with Donatello; his "Feast of Herod" is among the earliest examples of a complete and consistent use of linear perspective. (The theoretical work, however, was probably done by Brunelleschi.)

Almost nothing in Donatello's work sets out linear perspective in its pure form, for reasons of the greatest historical and theological importance. Of all the major artists, Donatello most clearly understood both the possibilities and the dangers of a great invention such as linear perspective. A closer look at "the Feast of Herod" might show both more clearly (fig. 24).

Nothing we have looked at so far quite prepares us for the extraordinary intricacy of the "Feast of Herod," an intricacy that is not fully understandable if it is placed off in the historic past. It is a singularly modern work, not in a condescending sense but in the sense of dealing profoundly with

issues that most other people were not aware of until the twentieth century.

It is not simply that the artist has multiplied the events in a single panel. There is ample precedent for including several events within the same frame, going all the way back to ancient times. Earlier presentations were, however, discursive. The several events were simply juxtaposed with no particular relation to each other beyond the story they told. Donatello, on the other hand, uses the juxtaposition to tell the story, to comment on the story and to set out the narrative structure that informs the work.

Salomé is in the act of dancing, balanced on one foot, looking aghast toward the other side of the panel where the servant is presenting the consequence of the dance; event and its result are one. In the rear the servant carries the platter with the head that defines who the servants are. They are not a crowd without character for they respond to the passage according to who they are. The three pages in the background are startled into fascination, the lute player bends over his instrument completely absorbed in his music. The bull-necked bravos, those indispensable instruments of tyrannical courts who could, on order, decapitate a saint, are cruelly indifferent. In the foreground the responses are, appropriately, more intense and more varied and a new thing in art is established. Character and personality replace types and abstraction at the center of an artist's concern.

Character and personality are only in small part revealed by external appearance. They are manifested only in what we do. Donatello's principle (taken up and treated profoundly by Leonardo da Vinci) was to show a single event and the varied responses to it, thus establishing a profound psychological unity in the work and demonstrating the great differences in personality.

The space is not simply a demonstration of linear perspective. It is both setting and commentary. The dividing wall

cuts off a stage space within which the event is enacted but the space goes back layer upon layer in a way that is simultaneously intelligible and mysterious. The mystery deepens in the upper right hand corner where the representations of space suddenly become irrational, inconceivable.

But the rationality of perspective space has its own psychological mystery. It recedes forcefully from the picture plane, thus creating a Renaissance space on the other side, away from the spectator. Then, in a variety of ways, Donatello denies the depth and flings the event back against the spectator's consciousness. Attention, therefore, is drawn into the picture by way of the great central gap, reverberates sideways to the event on each side of the center, then turns back to the spectator again.

It is one of the few truly epoch-making works. It did not cause the subsequent development of consciousness; it is too small and obscure a work for that. But it marks the beginning of a process that is only now coming to fulfillment. Time and space interlock, each interpreting the other and the two functioning both within and outside the story.

Even more important is the complex relation set up between the work and the spectator. On the one hand the event is remorselessly there, beyond and other than the world of the spectator. On the other hand the spectator is both drawn into it and compelled to accept it into himself.

Thus there is a good deal more going on than simply probing into the inner life of either spectators or actors. Outer event and inner life are inextricably involved with each other. The one is known by its reverberations in the other. This is seen in the representation of the work and felt in the response to the work.

There is present here a sense of wholeness, of comprehensiveness, rarely if ever achieved before and difficult to sustain. On the one hand, the complexity of character which this work makes possible is a permanent possession of the

human spirit. On the other hand, the variety and comprehensiveness of it tend to split up into separate investigations which have engendered some of the most remarkable achievements of western man. Yet the very achievements themselves become a threat when they are developed in isolation. Of all these, linear perspective makes the best test case.

A complete account of this remarkable device would be coincident with the history of western art for 500 years, which is beyond reach now. In the meantime, much must be said. It was revolutionary; it did give unprecedented control over picture construction. It did give so strong a sense of an accurate representation of the world that to this day historians title their chapters dealing with it as "The Conquest of Reality" or the like.

Unfortunately, it is no such thing. We now know that every one of its basic assumptions is wrong and, as I shall try to show later, we have paid a price for the dominance of this device.

Nevertheless, it was one of the most remarkable inventions of the human mind and made an equally extraordinary contribution to the western enterprise. But what it did was place the human observer over against the world. The basic principle of linear perspective was the organization of appearances on a plane surface according to their relation to a single human eye. This meant two things.

First, whereas in all earlier art, the art work was a specially constructed object in the same world as the spectator, now the art work created an imaginary world which was on the other side of the picture surface from the spectator. The picture is, then, in Alberti's term, a window onto an imaginary world.

Second, by definition, the spectator stands apart from that world and his only relation to it is through the eye. It is not quite true to say that such a situation had never existed

before but there was certainly no precedent for this particular combination of relations between the spectator and the work of art.

It is important to note, without further explanation, that not only Donatello but other artists seemed perfectly aware of all this and managed quite well to use perspective as one tool among many to make the pictures they wanted to make. They were quite capable of using many resources to reach across that gulf and relate the work to the spectator. There are very few examples of textbook consistency in the use of linear perspective and those few are usually exercises or else they are used precisely as a foil for a contradictory statement.

Nevertheless, a new psychic situation had been established. The spectator was detached from a constructed world which he observed from the outside. The relation between man and the world had been redefined. In short, Descartes had become inevitable.

At this point the question of the "Renaissance" becomes unavoidable, for all of this is inseparable from the achievements of the Renaissance and may, in fact, represent the greatest schievement of the Renaissance. But it has only a little to do with a "renaissance" of the ancient world and even less with the conventional view of the Renaissance as an age that libérated man from faith into reason. What basically happened is far deeper than that.

The Renaissance, not the Middle Ages, was the true middle age, for it came between two massive cultural and intellectual syntheses. The first was the great medieval synthesis which had begun to break down from its over-loaded complexity by 1400. The second was the rationalist Cartesian synthesis that is only finally breaking down in our own day. The Renaissance is the age in between, the middle age which had a vision of synthesis but not the ability to achieve it.

The greatness of the Renaissance lies precisely in the fact

that it is not what it ordinarily is considered to be, an age of confidence, of pride, of reason. "Renaissance man," if he ever existed, was thrown into a world without the support of an overriding system, so he was often most acutely aware of his solitude and his danger. The Renaissance is most often characterized by its range, but the most profoundly developed part of that comprehensiveness was tragedy. The characteristic "Renaissance man" saw himself alone and fought out a place for himself within the untamed energies of the earth, eventually feeling his work overpowered by events. The popular taste that makes Leonardo the paradigmatic Renaissance man is right for all the wrong reasons. Leonardo was man alone. With his extraordinary abilities and knowledge there was no true place in the world for him. He never achieved a true human relation, left behind only notes, sketches, ruined or unfinished works.

It is also paradigmatic that, as a period, the Renaissance achieved only one brief moment of unity in its culture. For no more than two or three decades, in that remarkable epoch of the High Renaissance, the artists achieved such a union of grace, harmony and dignity as haunts the imagination of our own culture to this day. Yet, humanly, the thing most characteristic of that work is its context, for the artists turned only an unseeing eye to the world; the world that nurtured their work was one of the cruelest, falsest, most vicious epochs that has ever cursed a suffering humanity.

The humanistic "Renaissance," the rebirth of classical letters, was no rebirth at all but a desperate, despairing effort to find relief and security in the past. The same thing is true of the Reformation. We have ample reason to be grateful to both for all they have provided for us but we ought not to confuse ourselves about what they were really doing. They could not face the anguish of their own day and contend with it on its own terms so they fled to an imagined past.

Thus the real importance of the Renaissance does not lie

in the dream of order which it could proclaim but not achieve. It lay in exposing the human condition in its nakedness so that much could be learned about who we are that we cannot know from people in the shelter of large, synthetic ideas.

Donatello is not "typical," but then no single person of that time is typical and his greatness was such as to transcend the typical. He was one of the few who could transcend the anguish and tragedy of his age and neither be dominated by it or forced to escape into a vision of paradisaical order.

What, then, of the "theology" of this? I put the word "theology"—the knowledge of God—in my title but deliberately do not use it much in the text. The unknowable can not be known directly but only in the structures of response to it. This is the "narrative," that in its structures and energies embodies, gives body to, the forming experience from which the work of art is made. Donatello's vision is of the wholeness of human experience, an intensity of awareness of the depth and complexity of human character never before achieved by man, never after exceeded. He was, in his own work, a concentration and summing up of the imaginative traditions we have followed so far. His sense of the complexity of human character is a part of his Old Testament heritage but he could make it so empathetically powerful because of the tools he acquired from the Romans. Although as a Mediterranean man he was less exposed to northern Germanic art, his design nevertheless clings to the surface in a tense interplay of vigorous lines that carry a major part of the expressive force. The union is Donatello's own and represents his Renaissance Christianity.

There is such a thing as "Renaissance Christianity" and the break that is so generally understood to have taken place only confuses the understanding of history. It is in significant ways a faith different from its predecessors since, contending with different problems, Renaissance Christians de-

veloped a new language to speak in. But we are dealing with
shifts within continuity, this time in the sense of the relation
between the human world and the divine. In the early
period, the sacred space was a fortress set apart from the
fearful world inhabited by enemies. Gradually the sacred
space flowed outward into the experienced world and it was
no longer a fearful place but radiant with the grace of God.
In no way did the so-called Renaissance differ from this view
fundamentally. Their predecessors felt a continuity between
the divine and the human worlds. Now there was a much
more realistic sense of what it was possible to say about the
divine. The divine world was apart from the experienced
world and unknowable except by mystical illumination. It is
no accident that many of the truly adventuresome minds of
the Renaissance became mystics or intense pietists at the end
of their life.

But the power of the divine is present in the experienced
world and known in its effects. The work of most of the art-
ists as well as most of the thinkers was, in their mind, en-
tirely a part of their devout service. There were, of course,
as many hypocrites, apostates, and self-centered people then
as there are now and they could take advantage of the situa-
tion too. But they were not legislative for the times. The
Renaissance was not an "age of reason" or an "age of adven-
ture" over against "the age of faith." It was the same faith
modulated into a new key.

Yet every act contains its own destruction. The Renais-
sance vision could not be forever sustained. Man had been
defined as a spectator observing a world from a single point
of view. The results were extraordinary, in every field of ac-
tivity. But the Cartesian dualism was inevitable.

Until that fatal end, however, the artists produced an as-
tonishingly varied body of work. It was as though every ele-
ment of the western tradition was being isolated and devel-

oped in rich detail or fused with other elements in ever new, ever renewable combinations. The Italians, descended from Giotto and Donatello, used the organic human body as the one prime instrument of their work. A German such as Dürer was perfectly capable of learning the uses of the body but also no artist so effectively fused dramatic action with the nondramatic energies of the northern interlace. The light that transformed the medieval church appears again in Flemish painting, is sought in a quieter mode in Dutch art, gleams through the profundities of Velasquez, flowers into impressionist painting and trains the western mind to a sense of space, without which twentieth-century science would have been impossible.

This is sample only and can be no more. What we see is the most varied and far-reaching exposition of the modalities of the soul and the soul's relations ever achieved in a single human enterprise. This is no reason for our characteristic pride, particularly for those of us who have not begun to learn how to use this heritage. The work of too many people in too many cultures went into this achievment for us to feel that the achievement is private to our culture. Our task, rather, is to know it and by its example know all those traditions they did not know or could not use and then learn how to fuse them all into a new sense of humane purpose that fits into the language and the problems of our own day as Donatello and the others were able to under the conditions of their own. There is no going back. The issue is nothing less than the human soul.

Since the period was so great, so comprehensive, any illustrations of it must be inadequate even when the choice is so comprehensive a figure as Donatello. There is a large body of work full of tender and peaceful gentleness that was nearly inaccessible to his intense style. As a sculptor he could make no contribution to many of the great Renaissance en-

terprises such as the profound explorations into the relation between man and nature that went on by means of landscape painting.

Architecture, too, is not represented in this account and the historical loss is serious, for Renaissance architecture in its absolute clarity of proportion both helped shape the modern mind and served as a great symbol of the essential creativity of God. Nevertheless, the intricate and complex spaces of Donatello's sculptures are more nearly a part of the process of spatial thought that has come to fulfillment in our own day and is so vital an ingredient of our own theology.

Out of all this extraordinary richness of insight, I choose only one other example and that so far at the end of the period art historians normally label it with that strange word "Baroque." I choose it because the crucial theme of Renaissance theology is the character of the individual and that theme came to a kind of fulfillment in Rembrandt, who may be described as providing the most conscious and deliberate presentation of the human soul ever achieved in any art.

Earlier I used Rembrandt's Bathsheba (fig. 7) in order to make a particular point, that Rembrandt does not see the general virtue fortuitously present in the individual who is less than the virtue or the human quality he exemplifies. Rather, for Rembrandt, all human qualities, all human possibilities, all human tragedies are integral with the particularities of a body and a particular history. Bathsheba's tragedy has no general meaning that is separable from the desirability of her flesh and the sensitivity of her intelligence. Rembrandt often chooses a subject of this kind, a human being trapped in a dilemma with no satisfactory way out, for in such situations the soul is born. So he presents the magnificent flesh set in the context of rich brocade and the indifference of the unknowing servant. The splendid head is isolated against the infinite dark that states more than de-

scriptions ever can the infinite loneliness of the human soul.

Rembrandt did not come to this by accident nor does it represent the mystery of genius more than any great creation does. It is discernibly based on his incorporation of certain essential elements of the tradition I have tried to describe.

Nowhere do we find a more profound investigation of the life that emerges from the depths of personality onto the surface of the face. This can be studied in the technical facility and emotional glibness of the early self-portraits to the depth of the late ones which appear to be no less than the flowering of the inner life onto the guarded and homely flesh of the face.

He achieves this in part by his sense of infinite space, developed through long study of the sea and sky of Holland. The space is then permeated by light, an effect he learned from his study of the atmosphere that suffuses the earth with the glow of the sun or which shines in a hut from the humble fire and the hidden lamp. The expressive movement of the body he learned from his endless observation and his profound study of the Italians. In all this he was the heir of the western tradition, the whole tradition, but what he did with it was his own, now ours.

We can see it in his "Jewish Bride," balancing tragic sensuality with happiness. The figures stand against the infinite blackness of space that surrounds them—but now there are two. They are enclosed in a great single arch and their upper bodies in a circle. The gold of the young man's sleeve gleams through the dress of the girl as her red gleams in the gold of his sleeve. Gently, he takes possession of her flesh, gently she receives him. With infinite tact Rembrandt has set forth the sexual union without so blatant a statement that all else is lost in the sensuality. Rather, it is taken up into the whole. The looks of their eyes do not exactly meet but cross;

they are, for all the profundity of their union, separate persons. In all, they glow with an unearthly light that raises their human ordinariness to supreme value.

At an emotionally quieter level we have one of his last works, the "Syndics of the Cloth Guild" (fig. 25). In his youth, he was a highly successful portrait painter; his famous "Anatomy Lesson" is the finest piece of commercial portraiture ever done. A whole career of art lies between it and the Syndics. He brings to this the supreme mastery that only a few ever achieve, so nothing is exaggerated, nothing is extreme. Six men are placed simply before a wall. They are held together by rising and falling horizontals, by the unity of tone over the surface, above all by the common action. The attention of each man is focused on one point which is outside the picture and in the room. We do not know what happened to attract them and it does not matter; the point of their attention is each of us.

They are not important men. They are five Dutch business men and their servant. They are ordinary men, perhaps even dull men. It is not a question to ask in the presence of this painting. Light, color, the mass and movement of the flesh, the cubic depth of perspective space have been fused into one incomparable unity. With perfect mastery Rembrandt has reached over the distance between us and these men. We observe them, there in the integrity of the space behind the picture plane. But we are brought into their presence as they are brought into ours. They look into us, into the depths of our inner life, into our souls, as we look into theirs.

A colleague of mine in graduate school, a tough, scholarly type, gregarious and extroverted, said of this picture, "It made me love my wife more." I did not ask him what he meant for I thought I knew. Our humanity is enlarged by the men and by the dimensions of that enlargement we are better able to love. The form of art brings about the birth of the soul.

Were I to present a fair picture of what Rembrandt stood for and the source of his work, I would have to present his interpretation of the gospel story. The Christ was the center and meaning of his experience. But, without space to do it fully, it is better to leave that in the background and see the results where Rembrandt would want them seen, in the lives of ordinary people.

The work still to be done represents in good part a continuation of the development I have tried to chronicle here. Yet in other ways it is a break, one of the most consequential and revolutionary in human history. It would be well, therefore, to summarize what I have already tried to do, by implication or by assertion.

I have attempted to isolate certain major themes of western culture since classical Greece. This in no way denigrates the achievements of other cultures; I have made it a point to emphasize that they are true explorations of genuine modes of being human. The brief mention of Egyptian art represents one of these modes.

The themes of these chapters have been embodied in certain revolutionary achievements. First, the Greek achievement preceded and probably caused their better known achievement in formal thought. They isolated and set out with unparalleled clarity the great simple themes of human life, exemplified in their great narrative. Later, in the Greco-Roman context, we saw the transition to the great Christian theme, the inner personality. Drawing on the resources of many traditions, the artists of Christendom explored the theme of the individual personality with a distinctive and private will. This developed to a kind of culmination in Rembrandt. Thus we have seen the chronicle of the forming of the soul.

This intensely private person lived in a world of intense personal relation, lived in and not of the world, in but apart from the world. This was his possibility but also his tragedy;

a prime symbol of modern man is the private individual, full of self-awareness, developed fully in personality, isolated and painfully, tragically, alone.

Linear perspective and Cartesianism cut us off from the world. The great work of modern art has been to put us back into the world.

Whatever we learn from Egyptian or Greek or Celt, from Donatello or Rembrandt, their worlds are not our world. Our problem, our mission if you will, is to do in our world, under the condition of our world, the work they so nobly did in theirs.

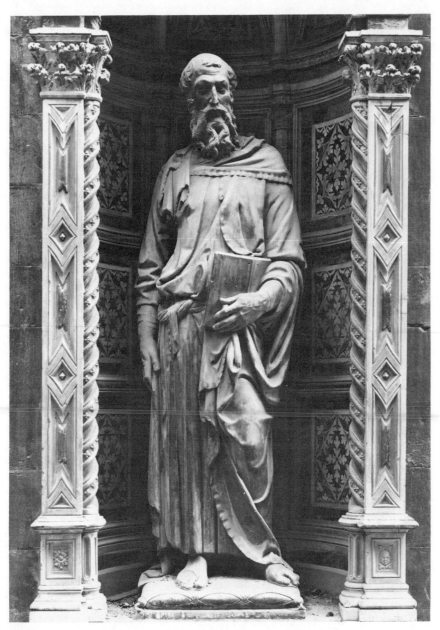

Figure 19. Donatello, *St. Mark,* Or San Michele, Florence

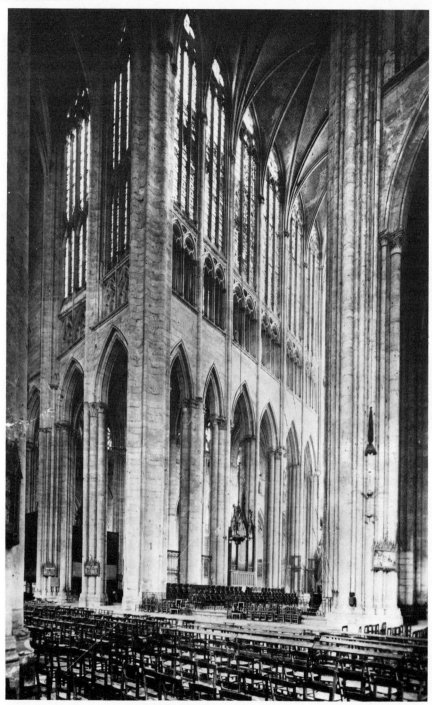

Figure 20. Beauvais Cathedral, interior

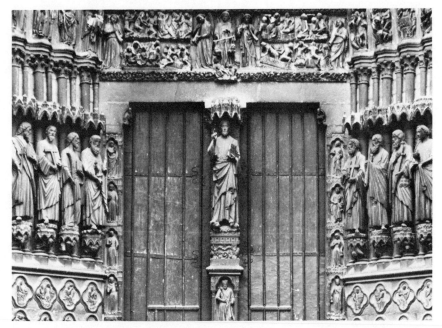

Figure 21. Amiens Cathedral, Apostles from Central Doorway, west front

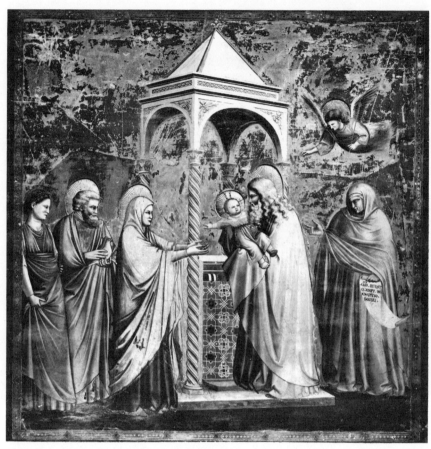

Figure 22. Giotto, *Presentation in the Temple*

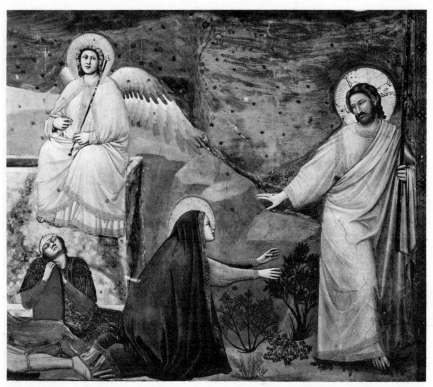

Figure 23. Giotto, *Noli Mi Tangere*

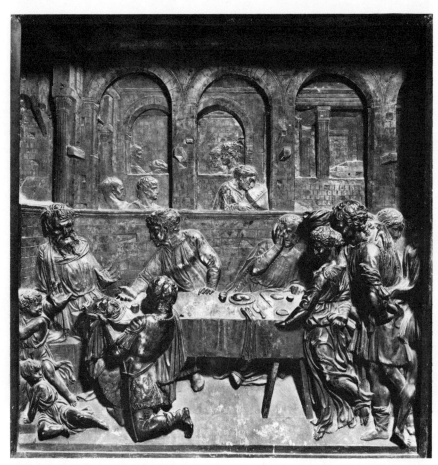

Figure 24. Donatello, *Feast of Herod*

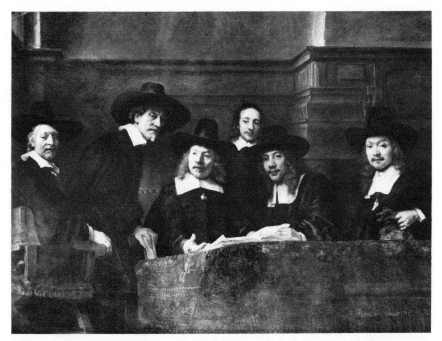

Figure 25. Rembrandt, *Syndics of the Cloth Guild*

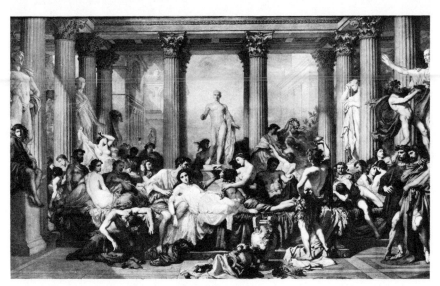

Figure 26. Couture, *Romans of the Decadence*

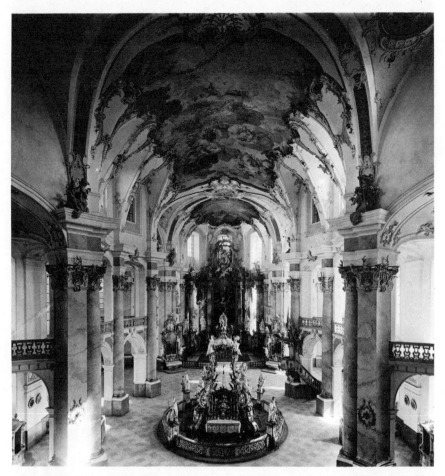

Figure 27. Balthasar Neumann, Church of the Fourteen Saints
("Vierzehnheiligen")

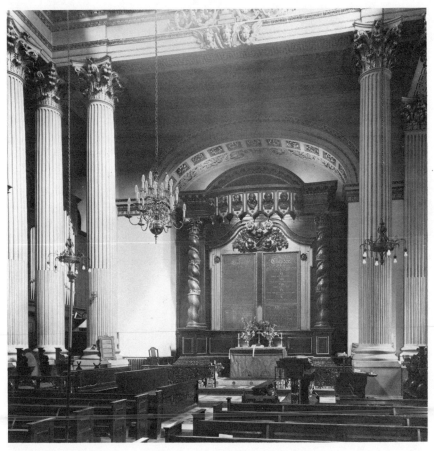

Figure 28. Nicholas Hawksmoor, St. Mary Woolnoth, London

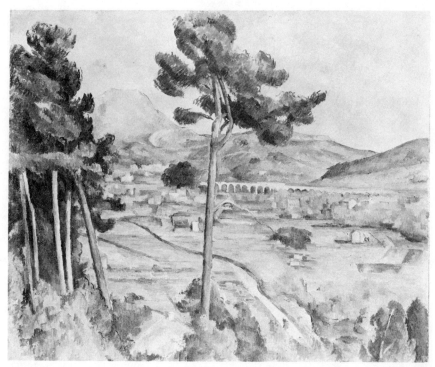

Figure 29. Paul Cézanne, *Mont Sainte-Victoire*

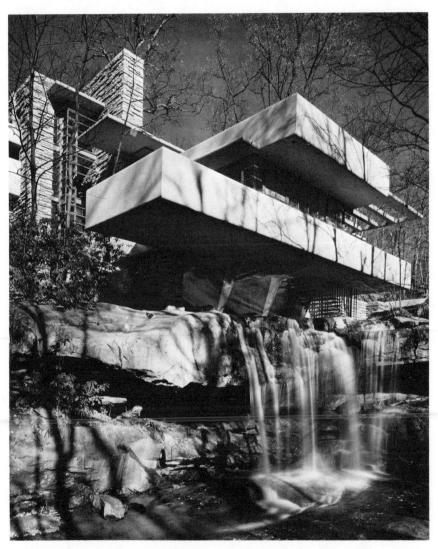

Figure 30. Frank Llo Wright, Kaufmann House ("Falling Water")

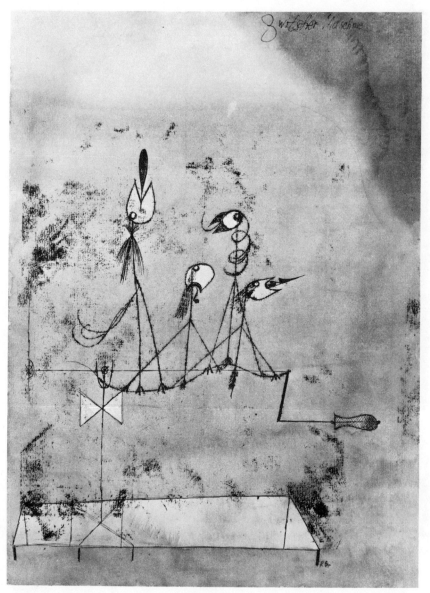

Figure 31. Paul Klee, *Twittering Machine*

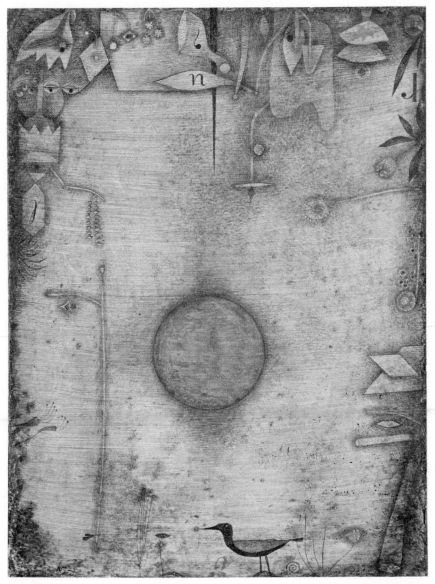

Figure 32. Paul Klee, *Ad Marginem*

six

THE SOUL'S NARRATIVE AND THE END OF STORY

Trafficking in large historical generalizations has been so discredited for such perfectly sound reasons that doing more of it requires considerable justification. After all, they are usually wrong and always do serious damage to the specificities, which is where we live.

Nevertheless, it is precisely in specificities that we are able to raise a most serious question: it may be possible to speak to some purpose of a period of time with its own unity and integrity.

What we can see, specifically, is that at the beginning of the fourteenth century, Giotto was making paintings that can be accounted for, with grave loss, by some such formula as this: three-dimensional bodies acting according to determinable moral principles in a three-dimensional space. It would be difficult indeed to find any or many works prior to Giotto that can be described in just these terms, particularly if the complexities of the word "moral" are taken into account. "Moral" refers only incidentally and derivatively to the question of right and wrong behavior. It refers, rather, to the capacity to make consequential decisions and, in this case, would include the study of both character and purpose out of which the decision emerges. A "moral" work, such as

Giotto's, is thereby differentiated from those works whose figures exemplify some general quality, some abstract truth or relation, some idea. The situation of the "Battle of the Centaurs and the Lapiths" is a moral situation and the participants in it would be making consequential moral decisions. That is implicit in the situation but it is not the primary interest of the sculpture, which is concerned to set out a general idea of what it means to be human. The moral does not have to do with the typical and the general but with the concrete and particular.

Or so we think, for we act under the instruction of Giotto, who first made this principle so intensely present to the mind of our people. We cannot know truly whether we have, through Giotto's agency, achieved an abiding truth or whether we are still living within the confines of a culturally determined principle. In any case it is an image of the human that dominated the imagination of western man for nearly 500 years. For when we turn to nineteenth-century academic painting, the style that dominated the art world then, we find exactly the same formula applicable. Three-dimensional bodies act coherently according to dramatic function in a three-dimensional space. The problem is that the example chosen (Couture's "Romans of the Decadence," fig. 26) is a very bad painting.

Quality has not been an issue in this discussion so far; everything considered has been, according to most professional judgments, a work of high quality. The only reason for bringing it in now is to accent both continuity and change. It is as true of the language of art as it is of every language; there is a distinction between the language and what is said by means of the language. Equally we now know that the structure of the language itself is as much a part of the structure of consciousness as the statements set out in the language. Thus it is important that Couture's work is, if not the same as Giotto's, at least recognizably in the same lan-

guage. It is equally important that the painting is bad but more important to know how it got that way.

Superficially it looks superior. The space is more intricate and under better control. The figures move more fluently with a vastly greater variety of pace and act. Technically it is an accomplished work. What then is wrong with it?

The most concise way to put it is in one word: discontinuity. By now everything that was a joyful discovery for Giotto is a technical trick. Every aspect of Giotto's work emerges from the story and returns to it to illuminate its human significance. For Couture, everything exists for its own sake only. Even the story is a blatantly obvious and altogether contrived device: the statues of the ancient Romans are frowning with stern disapproval at the antics of their depraved descendents. Part of the falsity of it appears exactly there in the subject matter; the painters had ample opportunity to dwell on the charms of the subject while ostensibly condemning it.

This game is being played with loaded dice. Goya, one of the great narrative artists, died only twenty years before this picture was made and Delacroix lived for many years after. Any full study of narrative art would have to take into account the work of Manet and even some twentieth-century art.

Yet this does not fully solve the problem. Goya and Delacroix stand at the end of the tradition begun by Giotto. Manet and Picasso are responsible for transposing that tradition into a different key. Couture and others like him stand on the border and it is important to know why he was what he was.

How accurate is it to present the tradition from Giotto to Cézanne as a single enterprise? After all, art historians divide it into many different periods and styles: Renaissance, Mannerism, Baroque, Rococo, Classicism, Romanticism, Impressionism, etc. Furthermore, within the technical con-

cerns of art history, the divisions have some validity. But it is a validity that depends on looking at it from within a single tradition. All those works have more in common with each other than they do with the works made after Cézanne. They are parts of a single tradition.

The difficulties of large generalizations about history appear graphically in comparing art history to intellectual history. Art historians customarily mark a break between "Renaissance" and "Baroque" about 1600. Before and after that date there are dramatic stylistic polarities of the kind that German scholars are so fond of. For example, compositions that had been displayed from side to side like actors on a shallow stage now are arranged so they recede into depth. This is no simple change; in the earlier style the action is displayed to a spectator outside it; whereas in the later the direction of the action more forcibly involves the spectator in it. There are other changes of equal psychological importance.

Even so there is nothing in the history of art to compare with the cataclysmic shift in formal thought that took place around 1600 and the following decades, a shift that transformed the intellectual world with great influence on other forms of life. Nothing in art history corresponds to the break that followed Galileo and Descartes.

The mythology of the Renaissance has considerably confused the general impression of what actually took place. Formal thought rarely had the kind of clarity and reasonable dignity of the Athenian philosophers. The Renaissance thinker was usually a magus, and magic (of a highly sophisticated kind) was the major characteristic of the Renaissance philosophic mind. Bruno's thought had great influence on later developments, a creative influence at that, but Bruno was a magus; what went up in the smoke of the Campo de' Fiori was not the precursor of the new age but the last of the old.

There is a very good reason why there was no comparable

break in art at that time: the artists had been living in that new world for a long time. The critical problem can be formulated in the title of an important study of Bruno and his age, Alexander Koyre's *From the Closed World to the Infinite Universe*. There are tidy, limited enclosed works in Renaissance art, for no period imposes some mystical "zeitgeist" or "weltanschauung" on everyone living at that time. But the movement I have sketched out in the last chapters and this one began with a sense of man facing infinity and trying to cope with it. The Celtic interlace is a screen against a deeply felt infinity beyond. It is rare, indeed, that infinity has been so deeply realized in a work. That planar screen then spreads across the massive blocks of the Romanesque and infinity is placed against power. But then the screen dissolves the massive wall and becomes architecture itself; the Gothic cathedral is one of the greatest of all symbols of infinity.

Early Renaissance architecture is less a symbol of infinity than it is of the control that geometry exercises over infinity as its true and inner meaning. This same motif appears in the other arts but a powerful element in Renaissance art, illustrated by Donatello, is the deep and subtle exploration of the interaction between the intricacies of space and the subtleties of dramatic relation. It is this, not the mere presence of accurate reproduction of detail, that constitutes Renaissance humanism.

It is this, too, that the artists of the so-called Baroque period took up and developed. All of Baroque art is an essay on the subtleties and intricacies of space. We might select as illustration two works almost contemporary, which were very nearly the last significant contributions made by ecclesiastical architecture to the creative imagination for nearly two hundred years. One is Balthasar Neumann's Pilgrimage Church of the Fourteen Saints, classified as Bavarian Rococo although it is actually in Franconia (fig. 27). The other is Nicholas Hawksmoor's St. Mary Woolnoth in London (fig. 28).

The one is German Catholic, the other English Protestant. They demonstrate clearly how lovely the differences between these two forms of Christendom can be yet, in their essentials, how unimportant. Originating in different cultures, widely separated in space, they are nonetheless very much of the same imaginative and theological vision.

Both buildings are, on the exterior, reticent about their interiors. Their differences are great on the outside but their attitudes are much the same. Vierzehnheiligen (as it is generally known even in English) is the lighter and more graceful of the two, but in both cases the outside turned toward the world and the weather and is correspondingly sober and careful and, in the case of St. Mary Woolnoth, exceptionally strong. The interiors are something else again. Vierzehnheiligen is all white and gold and pink and blue, all delicacy and lightness. It has two altars, not one, the normal high altar and the great pilgrimage altar itself. Thus the interior spaces are delicately dynamic and varied. Arches sway across the interior and touch in a dancing curve, the foliage of once sober Corinthian capitals flowering out over the entablature. Everywhere there is the delicate dance.

There are two conclusions to reach from the argument of this church. In the first place, as a structure and as a composition it is a clear and coherent statement of matters which are by no means easily made clear. Seldom, if ever, in the history of architecture have space, light and movement been so fused into so focused a unity. The experience of it is both a flowing outward and a turning inward. Grasping the space requires participating in it and there is no way to experience it without physically, bodily moving through it. Equally the space is open and free. It does not dominate but invites and encourages.

The second conclusion has to do with the emotional quality of this remarkable building, for, in fact, the dominant feeling has almost nothing to do with this clear intellectual order. The dominant feeling is pure joy.

Joy is a constant claim and affirmation of Christianity. It is not often achieved in persons and very seldom in any art other than music. If the list is confined to those works that manifest and communicate joy rather than representing those who feel it then it becomes even shorter. Of all, this is the greatest and most effective.

Nothing in the building gives any somber or tragic note, anything to detract from the architectural dance and the general gaiety. Nearly naked cherubs dance cheerfully along cornices; the shock to puritan asceticism is greater in other such churches when the leg visible above the cornice is not that of a child but of an eighteen-year-old girl. Probably the reply of a parishioner to the puritans would have been or should have been "Is not the leg of a girl one of the lovely things of the earth?"

There is no mystery such as Donatello brought into his relief but the involvement of the worshippers is equally complex, the delighted flowing outward into the encompassing dance but a liberty of feeling to look inward at one's own participation.

Thus multiple centers and axes and diversity of movement both contain the infinite and set up the participatory flow outward. Directionality is far less dominant than in most such buildings. There is, obviously, a powerful directionality in the movement from the entrance through the pilgrimage altar to the high altar. But this direction cannot be followed. It can only be seen and understood. Actual movement through the building is a matter of indirection, following the natural curves. So the axes of the building are much like the structural skeleton. The arches appear quite impossible; arches simply do not behave this way. Yet clearly they can do it since the building is perfectly solid. So there is a delightful dialogue between the form of the building and its underlying structure. The dialogue between the axes and the multiple curves of the building is a good deal more evident but equally deft.

So the building is a constant movement from multiplicity to unity, from unity to multiplicity, a pure dance of the mind in the context of rejoicing.

St. Mary Woolnoth is a work of a wholly different emotional temper while its essential formal attitude is approximately the same. Using it is a little self-indulgent; this church is not quite so central to the history of the religious imagination as all that. But it represents, with the exception of the work of Thomas Cranmer, the finest contribution of Anglicanism to art, and certainly, with the churches of Christopher Wren, the finest contribution to the so-called visual arts.

The architect of this, and other notable churches, was Nicholas Hawksmoor. It is a pity that, when the nature of Anglicanism is discussed, the sources are Henry VIII, Cranmer, Hooker, Pusey, Newman, Temple and similar worthies. I think it rarely occurs to people to consult Hawksmoor and Christopher Wren.

The issue is too complex to pursue in this context and, unfortunately, Hawksmoor's spaces are too subtle to be caught photographically, so I can linger for only a moment. The ecclesiological issue is the placement of the altar in relation to the congregation; is the church centered on the act of the priest in celebrating mass or is the purpose of the church to give shape to the corporate life of the gathered community? To what extent is the community a unit, a whole, and to what extent is it made up of individuals freely gathering in a common group?

Hawksmoor would not be so great an Anglican were not *all* these elements present as they are in few other Christian churches. Happily they are not present in the spirit of compromise illustrated by the immortal bishop who said "There are two opinions about the existence of God. Some believe he exists, others that he does not. As usual, my position lies somewhere in between." In Hawksmoor's case they are all

present *pure*. The interior movements center on the altar, which is powerfully held in its niche opposite the entrance. Yet the form of the church is central, a square within a square, shaped around the worshipping congregation. The congregation is shaped into a single unity by the balance of spaces penetrated by light. Yet the light lifts up the individuals to an ecstatic sense of their own intensely personal existence.

This achievement owes nothing to argument or to doctrine but is a structure of forms engendered out of a symbolic order. It is not derivative from argued opinion. As Ian Nairn, an architectural critic, said of another of Hawksmoor's churches, in bad repair, ". . . if the Church lets it fall down—it might as well present a banker's order for thirty pieces of silver. For here is the faith manifest."[1]

This is accomplished entirely by formal means. It is Baroque space, and while it is peculiarly English in the distinctive combination of lucid intelligibility and mystical ecstasy, it is English Baroque. I have tried to suggest that the Baroque period has its distinctive formal characteristics, with Baroque artists exploring further the basic symbolic order that has dominated the western mind from the beginning. In its specific function, as the way to the twentieth century, it pressed to its limits certain of the possibilities of the interactions of space and mass, of light and geometry, and principally of energy and solidity. Rational and intelligible space was pushed to the limit.

It is perhaps inevitable that any account of the church becomes deeply personal. All responses are, obviously, personal but there is here a more intensely personal, individualistic note than, say, in Vierzehnheiligen where the joy is communal. Here the first sensation is of a profoundly meditative quiet. There is a stillness about the room, a calm, pure cube surmounted by a half cube filled with light. But then consciousness awakes to the fact that there is not simply the

central space but aisles around all four sides which are themselves large enough to be independent yet held in both tightly and darkly so that they are syncopated against the principal space. The mind absorbs the precision of proportion but it is the emotions that absorb the purity of the harmony in the way that music is absorbed in its own terms.

Again, there is the dialogic response, the spreading out into the intricacies of the building, an awareness of the reverberations of the spaces in the inner recesses of the soul. As in Vierzehnheiligen there is a central axis, although a gentle one. But ultimately the focus of the church is on the worshipper who must, under judgment of the church, come to terms with himself.

An analysis of painting and sculpture would reveal both the same range of difference around the same deeply felt unity of vision. The paintings of Velasquez are as intricate an essay on the harmonies of space as Hawksmoor's churches. Velasquez and Rembrandt are among the great interpreters of lightfilled space. And so the catalogue could continue throughout Baroque art with its systematic and penetrating researches into the placement of man within infinity.

It is for these reasons I asserted that there is no such marked transformation in art as there was in formal and scientific thought around 1600; the artists had been exploring that world for a long time. Descartes' cogito is an acceptance of the implications of Brunelleschi's perspective. The new astronomy finds its imaginative ancestry in the Celtic interlace.

With the privilege historians regularly use of shaping the account of history to suit their ideological ends, I could both easily and accurately trace this development right through the nineteenth century and present the linked chain that ties together the ancient and the modern. It would be accurate but only selectively so. The researches went on, but far from

the dominant ideas in society. Now they were for an elite. Social thought in general had passed the inevitable crisis of positivism and the world was now a collection of things.

The problem with Couture and his colleagues is that they could not take their place in the true unfolding of the imagination but were captured by the publicly reigning ideas of the day. The took only the technique from the artistic tradition, the general themes that were now worn out. From the public culture they took the principle that the mind stood outside things, observing them and reducing them to submission to ideas developed outside themselves. Thus that extraordinarily complex world of forms was reduced to those aspects of it that could be controlled by the rational intelligence (i.e., the conscious, purposeful, verbal intelligence).

The inevitable result was that everything including paintings was reduced to inert thingness. Much that has been said of the Renaissance does not apply at all to the Renaissance itself but does apply to the nineteenth century. For the truly creative artists of the Renaissance the work itself was an act of magic to take hold of, to control the ineluctable reality they felt so intensely. Academic art of the nineteenth century (like so much of its written theology) was the art of reason, the art of an arrogant pride bent on dominating the human experience.

The result was an art of a singular inertness. Art nourishes itself on its intimate relation with the visible world (significantly enough, the work of Couture and his fellow academics was fresh and vigorous in sketches and small informal works). When the calculating intelligence intrudes into that intercourse, seeking to control it rather than serve it, then all the life goes out of the work and art becomes pretentious, artificial or, as in this case, pretentiously silly.

The concern in paintings such as this is not to provide an opportunity for the release of tensions or for a display of

elite pride. The problem of this painting is much deeper than that. These painters mark the transformation of the great narrative art into anecdote. Given the grandiose intention of much of this anecdote it is well to define the term: anecdote is a story which has lost all narrative weight and is merely recorded incident. Official art had become as trivial as it has ever been.

Causality is a difficult thing to trace in any context; it is just as difficult in the case of nineteenth-century academic art. Yet it is worth doing lest we fall into the temptation of attributing to them some unique evil, stupidity or mendacity. The situation that created the comic pretension, the inflated vulgarity, the moralizing pornography of Couture's "Romans of the Decadence" is the situation that created the unique problem of the modern world.

The problem is universally human. We develop a symbolic structure to cope with particular circumstances. That structure teaches us more than it itself can handle, thus generating a new problematic situation. Its techniques are no longer fresh ways of exploring the world but inert rules to be used by rote. The world, existence itself, becomes problematic. The human choices are widely varied and logically limited. There are artists who are willing and able to keep repeating what has already been done. Those who are creative in their intention can only cast about wildly, desperately trying everything they can as a way out. Others sink in apathy, overcome with the uselessness of it all. Still others flee to private indulgence as an escape from the dead and ugly reality they have inherited.

This was the situation in the nineteenth century; it is the situation of our own day. The form this malaise takes is itself derivative from the forms being rejected. I have tried both to chronicle the changing mode of the spectator's involvement with the work of art and to suggest the consequences of the change in the more general work of the human spirit.

On the one hand, beginning in late Hellenistic Rome, we have seen the steadily, if irregularly, developing concern for works that compel the spectator to turn inward to contemplate his own responses. On the other hand, we have seen art works so constructed that the spectator has been transformed into an observer of an object with its own internal order, more or less excluding him.

These developments should not be understood as two separate strands of intellectual history. Rather they interact in an extraordinarily complex way which we can deal with only very crudely with such terms as "objective" and "subjective." In western art the most acute and precise observation of the external world interacts with an equally precise exploration of inner psychology and states of the soul to form one of the most profound documents in the study of human psychology to be found anywhere.

It was the task of the most serious Baroque artists to seek and sometimes achieve the fusion of the elements which had been so profoundly explored by their predecessors—the appearance of the external world, the states of the soul as caught up in the interaction of the formal structure of the work of art and the perceiving spectator. In this they were not being post- or anti-Renaissance; they were bringing the Renaissance enterprise to its completion. But since no symbolic enterprise is ever a permanent habitation of the spirit, this too could not be a stopping place. Yet the official artists of the nineteenth century tried to make it one, in order to suspend the process in the perpetuation of inherited insights. The result was a paralysis of creativity.

It is obvious that I take this case as both symbolic of and a manifestation of a general condition in the spirit of man. In fact, I do so beyond what I am willing to assert because it is beyond anything I can hope to demonstrate; it is impossible to know what is cause and what is effect, whether the art work is the source or the expression of the movement. But

official art dramatizes what is happening in the depth of the modern soul—and so it is, with all its ineptness in presenting the story, a true narrative art. It sets out what these people had made of themselves and their world.

The work was still being done. The true art of the nineteenth century was continuing the enterprise that had begun so long before. But it could not be done in such a way as to affect the common life, or to provide a formal language within which the spiritual life of the people could be enacted.

Nevertheless it was being done and it culminated, at the end of the century, in the work of a man who stands to the modern age as Giotto did to the Renaissance. Paul Cézanne is one of the few great epoch-making artists; he does not simply mark the beginning of a new epoch but he stands astride two, gathering up the achievements of the previous epoch, transposing them into the key of the new (fig. 29).

The form this took for Cézanne is of extraordinary importance for the understanding of the twentieth century. It reveals also how simple the most profound issues usually are.

The basic problem of *all* painting is the translation of a three-dimensional experience of the world into a two dimensional surface. *All* painting. There is no historic style before the twentieth century that is an exception to this principle; the most patterned work—calligraphy, various kinds of ornament, etc.—themselves create the third dimension by their placement against their ground. To one degree or another the disposition of this problem is a basic part of the language of art.

It is not simply a technical problem but a symbolic problem. It determines whether a work presents a view into its own world or is a thing in the world of the spectator. It has very great symbolic weight.

All artists must contend with the problem but not very many do so self-consciously. Their treatment of it is part of

their inherited language and incidental to their own development. Cézanne, however, placed that problem at the very center of his work. It was, for the major part of his career, an obsession with him to recreate the essential three-dimensionality of observed objects and spaces (particularly but not only landscape) within the two-dimensional surface of the painting. When he was successful (which is a good part of the time; he had a way of abandoning those that didn't work), the result is an extraordinary tension. The tension is physical in the work for it is the principle of coherence of the work's structure. In this respect Cézanne's work sums up one of the primary problems of western art, that tension between surface and depth, the eternal and time which is the singular western sense of the infinite.

But the tension is also profoundly psychological since it must be felt in the reality of its existence. Thus, to a degree seldom achieved earlier, the experience of a Cézanne painting must be a dialogue or even more. The consciousness must move out into the represented scene, into the structure and vitalities of nature. Then it becomes aware that these are concentrated onto the surface of the painting which is no longer a window into an imagined and reconstructed world but a thing in its own right with its structure and energies syncopated against and synchronized with the natural order. The consciousness that can achieve awareness of this intricate interaction becomes, then, intensely aware of its own working.

Thus the pretension of people like Couture to an independent command of experience is entirely overthrown. The relation between man and the world is a process, an interchange, a linking, that with passionate respect preserves the integrity of every element while respecting equally the forces that relate them. It is a vision of wholeness without parallel in art.

The way was prepared for the twentieth century.

THE OPTICS OF THE MODERN IMAGINATION

Self-indulgence claims that our sufferings are greater than the suffering of any other people, that the sickness of our own day is more oppressive than the sickness of any people in the past, that, indeed, ours is a sickness over against the health of those in the past.

It is, of course, not true. But it is true that our situation is different. To know the difference, both its dangers and its possibilities, is essential if we are to know what to do.

It is this requirement that complicates the task for this chapter. We cannot simply continue the exposition as though the problem of modern art were like the others. It is, in some ways; while the grammar of modern art is significantly distinctive, the vocabulary is the same. In other ways, however, modern art or the role of modern art is quite unlike anything that has happened before. We can, perhaps, understand the difference best by looking at modern art itself. Yet it might not hurt to undertake a little cultural description and analysis; as a culture we spend so much time in narcissistic self-analysis and have thereby developed so strong a sense of the primary importance of narcissism, of the centrality of self-fulfillment, that it would be dangerous or ineffectual to start anywhere else. Let us keep it brief;

such cultural comment is easy and it is fun; it is also easy to be glib and superficial.

. Actually, it is essential to do two things. First, we must have some descriptive sense of the problems of our situation. Second, we must have some analytical sense of the true and fundamental differences in our situation. If I take the second first it is, in part, to suggest a causal relation between the two.

Partly it has to do with our sense of matter and the reality of the material order and this in turn is inseparable from the discontinuity between our physics and our metaphysics. Our metaphysics, including the metaphysical base of theology and most art criticism is still, with all exceptions taken into account, essentially Greek. Our physics, on the other hand, is for all practical purposes our own. The two are very different.

The problem with Greek metaphysics is precisely that it takes seriously the possibility of making general statements that are, in some discernible sense, descriptive of the real, that are "true." We are so accustomed to that position that it is assumed by all sorts of people with apparently contradictory notions about the world. Despite everything it is still possible to hear that ultimate of all intellectual absurdities— statements that make the name of God the subject of various forms of the verb "to be."

Unfortunately, the dominance of this principle created an intellectual system that prevented the use of the very material that might have corrected it. If verbal statements are considered true, it is only a short step to the conclusion that verbal statements provide either the primary or, ultimately, the exclusive route to the truth. Thus, intellectual development was closed off from a serious study of the two areas of the mind essential to its fulfillment: optics and technics.

"Optics" here includes art but also includes more; it is the way we see the world and the way we see the world is, fi-

nally, inseparable from the way we think about it. The
Greeks suffered from a fatal deficiency in their visual lan-
guage, that they could make a visual statement about the
seen world only once for there was no technique available
for repeating that statement exactly. This simply means
there was no process of printing available to them and,
therefore, no way of reproducing images exactly. Now, the
only way I can know what you have learned in your studies
is to receive it in some form that records your work ac-
curately. You can make a drawing for me and a very few
others but that drawing does not reach very far. Thus the
exclusive instrument of Greek communication and educa-
tion was words. Words are remarkably useful instruments
but anyone who has tried to describe a flavor or the face of
his beloved knows very well the fatal limitation of words:
they can state only generalizations and never particulars.
Thus truth became identified with general statements de-
spite the fact that we live only in a highly particular world.

The people of Greece and of the eighteenth century, says
William Ivins, "could only be reasonable, for it was utterly
impossible for them to be right."[1]

Thus was created a static world of general truths and eter-
nal essences. Much philosophic revolt against this ordering
of the mind, such as existentialism, is not really a rejection of
it but a statement of dislike of it. Much modern development
in philosophic thought is an inevitable product of this philos-
ophy: since statements made on such a basis were so mani-
festly absurd, reasonable and sensible people could only turn
their attention to the language in which the statements were
made.

Running alongside this development in verbal thought
were the intellectual developments which were truly decisive
for the western imagination. They are not thought of as
ideas since only words are considered to carry ideas but they
are, in fact, the vital ideas of our culture.

My self-assigned topic is optics but in no culture is optics

separable from technics; it will serve a purpose for us to note a little of our technics.

Lynn White, Jr. has established that the crucial inventions of our culture were such things as the stirrup, the harness for draft horses and, above all, the crank.[2] These are clearly economically important (and so traditionally not important for what we are pleased to call the humanities). But they are intellectually revolutionary because they contained a fundamental idea. Each invention is a way of changing weight or strength into energy. Thus the basic intellectual image is shifted from the static and unchanging to the dynamic and active. The key metaphor now is process and function. Later this carried over into finance; letters of credit and double entry bookkeeping change money from quantity into function and relation.

Our physics owes much to the power of Greek systematic thought but it owes more to the power of western specific observation and above all to the habit of seeing the world in terms of function, relation, change, transformation. These are the dominant metaphors of the western mind. They have now issued in an analysis which must become the bedrock and foundation in all thought, including theological thought in our own day.

It is not my role or competence to be a historian of physics. Let me, therefore, rely on a philosopher and a historian of science, Stephen Toulmin and June Goodfield: "Classical nineteenth century science was still in crucial respects a Democritean system: it treated the atoms of matter primarily as 'bricks' and left unsolved the problems of coherence and organization."[3]

It is exceedingly difficult to link the image of order which is physics to the images of order and of the self in the human imagination. Yet it seems clear that the juxtaposition reveals more than accidental similarities. Physics from Democritus through the nineteenth century is built on an image of discrete atoms, of separate units, related to larger

units by the force of their weight and by linear causality. This is still the dominant image of physical order among laymen and those scientists who are intellectual schizophrenics.

Equally, this image parallels and, in part, engenders the dominant image of human order. This image presumes isolated human units related to each other only by causal force. In ethical terms this means that the determinant of order is considered to be power and selfishness. The shocking thing is that such an image so quickly invaded and so easily conquered the church. A generation ago the church was as easily conquered by the conviction that it was its duty to serve one or another political and economic order. That incubus is still with us but it is close to being replaced by the wholly heretical rhetoric of self-realization, self-fulfillment, the determination of public order by private pleasure.

It is false history to deny the achievements of these images. The combination of Democritean physics and the power-driven isolated will has created the world we know and in many ways it is a very good world indeed.

Nevertheless, we are looking now, not at the creative and fruitful stage of the development, but at its fear-ridden and disintegrated later stages. In the actual event, the two developments became isolated from each other and we can see most clearly the extent of the observation when we see the confused and despairing response.

On the one hand, we have the idolatry of objectivity, the ideal of the detached scientific observer. So much of the experienced world is reduced to naked objecthood with no coherent relation to us as persons. Such objects can be dealt with only by a technique and the worth of the object is measurable by the logical consequences of the technique, not by either the inherent energy of the object or its relation to us. Nature is inert, subdued to the technique of the engineer. Sex is not a relation between persons but a technical transac-

tion. Politics is not a high art but an exercise in human engineering. An unborn child is a bit of tissue to be expelled or a cancer to be cut out. There has been a steady withdrawal of all things, including ourselves, into themselves, a separation from involvement or relation.

On the other hand, a wide variety of social phenomena can be understood as a frantic attempt either to deny this detachment and isolation or to affirm that, within it, the isolated self is the only final value. Major social relations and acts, marriage and divorce, sex, children, are determined as though the sole issue involved in them is the satisfaction of the isolated self. Drugs don't really enhance consciousness; they create a sensory world this person-object can hide in; people have no true relation to other people or to a community so they desperately create a world around stimulated nerves. The body is stripped, in hopes that the sight of breasts or thighs or penises will at least be a reminder that only a person possesses an intimate anatomy. With fierce, violent, hate-filled language, we shout our identity with some *thing* that establishes a relation to someone else—our gender, our race, our language, our nation, our politics, our church.

The tragedy is that the church has almost no intellectual resources to deal with this problem. The language of the church is almost completely untouched by the crucial developments of our day and so its public discourse is quickly overrun by fashionable rhetoric or retreats into blind reiteration of its ancient speech.

Yet the resources are there and they are to be found precisely where they are always found, in physics and in art. I will say only a brief word about physics and then return to my own subject.

Again Toulmin and Goodfield:

> The physicist's fundamental units are no longer bricks: they are now *dynamic* units, defined by characteristic patterns of energy and activity; and they join together

not in single chains or aggregates, but by forming out
of their separate wave systems stable "concords" or har-
monies, which have new capacities and activities of their
own . . . At every level of analysis, from protons and
electrons up to living creatures, the objects which na-
ture is composed of have to be characterized in terms
both of their structure and their activities.[4]

Thus we now have an image of order which defines mat-
ter as energy in rhythmic tension. All forms, all structures
are a part of the hierarchy of structures that extend from
the atom to the cosmos.

The question might be asked: must we be fundamentally
affected by this new image? Can I not pay my respects to our
greater understanding of matter while behaving according
to the manifest appearance of things? In a practical sense,
yes. I may know that the chair is not solid matter but is
energy in rhythmic tension, yet I sit on it confidently.

But, truly, the answer is no. In the first place, our minds
are too much changed to make effective use of the old
images. We have photographs of the earth in space and the
microscopic structure of things. Even our instruments of
popular entertainment set out a new ordering of space and
time; on television we see the play in the football game, see it
again in slow motion, again close-up and from a different
point of view. Time and space collapse into each other.

Even more fundamental is the fact that we now *know* the
inseparability of the human world and the natural world.
The basic vocabulary of physics includes words like function,
relation, process, interchange, transformation, system, struc-
ture. We know that the human organism is a part of the con-
tinuous hierarchy of structures that goes from the atom to
the cosmos. Therefore, the characteristically human acts, the
making of objects, of institutions, of structures of thought
and imagination are not added to the physical order but are
developments of it and within it. As matter, we—or what we
once could refer to as "our bodies"—are systems or struc-

tures of energy in rhythmic tension, a structure of relations in particular patterns. But all human culture is a matter of generating or developing structures of relation. This is the uniqueness of the human. Alone in the order of nature, we have the capacity to make something that is new in nature. But it is *in* nature and a part of the structure and process of nature, not something we have added to nature, apart from nature. The questions about mind and matter, body and soul have not been answered. They have been eliminated as false questions based on a physics which is not any longer supportable.

The new questions make the world of our habitation. The world we make is complete with its structures and relations, its rhythm and energies, its characteristic modes of interchange and of transformation. The incarnation of its processes is its narrative, the incarnation of its structure is its art, the nodal points of its energy are its gods. Its internal description, based on the very structures and operations it describes, are its theology and philosophy.

Theology is not the knowledge of God or the divine, it is not the description of the true. It is a verbal account of the imaginative and symbolic structure we have made. This is not a reductionist statement. It does shift the locus of authority from the verbal statement to the whole active and energetic structure—the narrative—which the verbal statement simply expresses. In a world of relation, process, transformation, it is the height of futility to use a language dominated by the idea of substance, fixed quantity and equivalence, which has been the world of theological assertion, of dogma, and of "Truth." We are not faced with a need to "demythologize," in so far as that strange word means to distill objective truth from myth into neutral language. All languages, all forms are functions in a relation; change any of the terms and the whole relation is altered.

The only way orthodoxy can be defined is as process and

relation, not as fixed and quantifiable substance. The only
way revelation appears, according to the principle of the In-
carnation, is in the world as it is, not as it was, in the forms
that actually make up people's symbolic worlds, not the sym-
bolic world of another people, even our own ancestors. We
study the forms of the past in order to learn the possibilities
of being human but also to learn the process of the soul's
formation. We study the present in order to learn the condi-
tion of our own work.

If orthodoxy, which is truth under the condition of a par-
ticular culture, is definable as process manifested in form,
our gravest need is to learn the very language in which or-
thodoxy is set out. The primary way to do this is to go to the
artists whose province and responsibility is the making of
symbolic forms. Art is not the only way the process, the nar-
rative, of a culture is made manifest but it is the surest
means of learning how form works and it is always a major
form in its own right.

A full history of western sensibility would almost certainly
not find a correlation between the various form develop-
ments at any one time. The pressures on western culture
have been too great for there ever to have been a single co-
herent development. Technics alone show a complete consis-
tency of development. Art does not, for its development has
constantly been torn between the psychological heritage of
the Old Testament, the formal heritage of Greece and
northern Europe and the internal logic and combat of its
own development. Even so there seems to be an intimacy of
relation between art and technics (and physics insofar as it is
responsive to art and technics). From the beginning western
art, too, has been concerned with the interaction of the finite
and the infinite, the art work as the moment of transition be-
tween inner and outer, as the point of intersection between
the inner world of the spectator, the outer world of experi-
ence and the transcendent world of the spirit. The samples

studied in this text give small sense of the extraordinary range and variety of this remarkable enterprise, a work without parallel in human history.

Since we cannot look into the intentions and purposes of other people, we cannot really say how conscious all this was among those who were doing it. It is well not to conclude too quickly that they did not know what they were doing. Equally, important formal developments take place within the possibilities of technology without any clearly defined non-functional purpose.

Most particularly, as Siegfried Giedion has so masterfully described, at the same time that dead academicism was dominant in the public arts, vernacular and utilitarian art was announcing something very new. The increased use of glass (made possible by the technology of both glass and framing) was blurring the distinction between inside and outside. While there was the extravagant and megalomaniacal development of the vertical skyscraper, there were along side that rich developments of the horizontal; verticality became less and less the symbolic theme.

By the time of Frank Lloyd Wright's earliest mature work in the first years of the century, the main themes of the modern mind had been set out in architecture.

1. The definition of reality as function rather than substance.
2. The definition of function as relation rather than power.
3. The dissolution of the distinction between inner and outer in favor of continuity and coherence.
4. The dissolution of the authority of the vertical (hierarchy) into a web of mutual relations.

It is worth pointing out that the crucial developments in modern physics—relativity theory and quantum mechanics—are exactly contemporary with the developments in art.

The decisive public statement of this new world was in the work of Frank Lloyd Wright (fig. 30) (rarely studied in seminaries as the crucial theological doctrine of our time). A far more private but equally decisive statement in painting was the work of Cézanne. The hierarchical vertical order, so crucial to so much art and decisive for politics, has no relevance at all to Cézanne whose compositions simply report the common fact that our vision is determined by our upright posture. Beyond that the decisive element of a Cézanne painting is precisely the complex series of relations, back and forth, side to side in the painting, in and out between the painting and the spectator.

Rarely has a single body of work had such a remarkably liberating effect. Like the breaking of a log jamb, in a very few years art began rushing violently over the intellectual landscape. Since art no longer had to serve any traditional definition it turned riotously to the exploration of every conceivable aspect of the world of experience Cézanne had opened up: the structure of the world, the process of the creating mind, feeling, dreams and fantasies, the intricate and infinite possibilities of the materials and techniques of art, any and all the historic themes. So rich and varied an exploration of the energies of the spirit had never before been undertaken.

To the layman, overcome and terrified by the apparent novelty and the unsettling variety of the new imagery, the one thing most desired was the one thing almost wholly missing—appearances. It is not an important omission because it was the one thing not required; after centuries of profound study the one thing we knew most about was appearances.

Nor is it in the least possible to conclude from this that modern art was anti-humanistic; art is dehumanized, not by the exclusion of the human from the subject but by the desiccation of the style. Academic art truly rejected the

human by suppressing the truly human under the dominance of formulas for the manipulation of appearances.

Once modern art had received its essential definition in Cézanne, once art had been defined as the whole relation of humans to their world, it became more, not less humane. For the overwhelming preoccupation of modern art has been the infinite variety of the human relation to the world. Continued preoccupation with appearance would only have inhibited this work.

The incredible variety of modern art becomes intelligible once it is understood as an exploration of all possible formal interactions of people and world and a considerable portion of the emotional and psychological interactions. Compared with their work philosophical phenomenology looks like a schoolboy's exercise.

To choose a sample from such richness is a process of frustration and despair. No choice can be truly representative. Yet I make my choice with a certain confidence and lightness of heart.

Paul Klee is an artist of the second generation, not one of the founding fathers. But he is the artist who most fully understood what had happened, refined it theoretically. His is not only one of the most important achievements of the modern mind; it is the one we can use *now,* into the future.

Klee occupies a strange position in the discussions of modern art. The primary concern of art historians is to classify artists and styles. Historians are very uneasy about Klee because he is impossible to classify. He is, perhaps, closest to cubism, but he does not quite fit as a cubist. His vocabulary is basically cubist: the real but shallow space, the color tones that push into and pull out of the depth, planes that lead into space but then come back out again. But there is an element of expressionism, occasionally a touch of late impressionism, a strong element of surrealism. So our classifying terminology exposes its own futility.

Klee is not classifiable because he is the one major artist who looks not to the past but to the future. What he offers us is not simply a finished work for our edification, although it is that beyond most oeuvres in modern painting. What he offers is a way, a process of being involved with the world in fidelity both to what has been done and to what is yet to be done. If theology can understand what Klee did it might be better equipped to redo its own work. It is, in good part, the way, the process for the religious imagination.

There is a striking physical characteristic of Klee's oeuvre: he produced not hundreds of works, but thousands; most of these are quite small and nearly every one is of high quality. Now, hack painters can produce a large number of works but few if any have any good quality. A very few great artists have produced a large number of works of high quality. Rarely does any artist produce so many works characterized by such freshness, and originality.

To those whose relation to art is confined to the few works a museum chooses to display, or to a few masterpieces, each thought out whole and existing as a freshly created world, this quality may not be obvious. To those who have spent their lives studying art, the oppressive thing is its repetitiousness. Even in the work of very fine artists, there may be many works of high quality that are not particularly new.

This is an inevitable consequence of the optical assumption I have been trying to set out. The artist takes up a particular point of view toward the reality of the observed world and his own technique. He uses his tools to make a work that becomes something apart from himself. When he directs his attention to another aspect of reality he produces a new work, full, perhaps, of vitality, of insight, of all those things that make up a "good" work of art. But rarely is it new, rather than a development of ideas already begun. One of the pleasures and instructions of the study of art is to see a great man generating an idea, nourishing it, exploring it,

testing it out, adding to it new and related ideas. It is of such material that the greatness of our tradition is made.

Such ideas concern form or subject or, in the case of most of the great artistic ideas, a subject wedded to a particular form. The process is, therefore, not unlike the logical process of deduction which subsumes particulars under a general principle and derives particulars from general principles. It obviously works to great effect. Also, it inevitably goes dead because no human idea is inexhaustible.

Why, then, is Klee's work so often fresh and new? Not because he himself, a very great man, was greater than his great predecessors. Rather, he redefined the making of a work of art and in doing so defined the conditions for fruitful work in the world we have made. He thought through the work of the artist in terms that create a new optics and a new way of working in the world.

Klee's own words give a clue. "The study of creation deals with the ways that lead to form. It is the study of form, but emphasizes the paths to form rather than the form itself" (p. 17).[5]

"What we are after is not form but function. Here again we shall try to be precise: the machine's way of functioning is not bad; but life's way is something more. Life engenders and bears. When will a run-down machine have babies?" (p. 59)

"For the artist, dialogue with nature remains a condition sine qua non. The artist is a man, himself nature and a part of nature in natural space" (p. 63).

"Art does not reproduce the visible but makes visible" (p. 96).

"Not form but forming, not form as final appearance, but form in the process of becoming, as genesis. . . . Thus form should never be regarded as solution, result, end, but should be regarded as genesis, growth, essence" (p. 169).

These are samples only (Klee's published writings run to

hundreds of pages) but they give a clue. Nature is all there is and man is a part of nature. Yet, unlike those who would thereby reduce man to the kind of nature we see in the garden or the forest or even the sky, Klee saw nature as whole and infinitely complex; its reality is not exhausted in any of its manifestations. Man is natural—but unlike any other part of nature. To deny nature is to violate himself. To forget his self would be to violate the processes of nature, since the human self is a part of nature. Therefore creativity is neither to impose a distinctively human order on nature nor to surrender the human self to the processes of a non-human nature, but to create according to the laws of natural forming, including the distinctively human.

It is well at this point to underline the religious implications of this position, as obvious as they may be. Clearly any culture, any religion, any work of art can be defined by its relation to nature. It is a peculiarly central problem in our day. The dominant cultural order postulates a complete separation of the human and the natural with the human absolutely dominant over nature. In reaction to this, many serious if rather unoriginal people seek one or another form of union and harmony with nature—Taoist or Zen meditative harmony, tantric sex with its obliteration of the ego, various other oriental or primitive formulations and their attendant disciplines.

I am not concerned with Klee's formal religion. It was there but he was fairly reticent about it. I am concerned only with his redefinition of this central issue.

For Klee it was not a matter of nature *or* the human. It was not even nature *and* the human with either dominant over the other. Rather his concern was the *process* which characterized the work of each in the wholeness of their interaction.

Therefore, it was essential for Klee, to a degree unprecedented in the history of art, to analyze the process of mak-

ing, of forming, into its elements. Nowhere is it more evident than it is in Klee's careful analytical procedure how dependent progressive modern work is on the tradition. The adolescent rebellion against the western tradition will find no comfort in Klee's work.

This analytical work was conducted through his teaching which makes up the bulk of his published writing. The books are full of analytical pedagogical sketches and diagrams but the analysis penetrates his work as well. Constantly he was seeking the formal equivalent of some particular element of the making of a work of art as of a work of nature.

It may begin to be evident why there were so many works and why so many are small: each is a tiny part of a large and complex process.

The analysis leads directly to construction and ultimately the two are part of the same process. It has discernibly several dimensions.

First, there is the analysis of the elements of the formal language. This is best, if incompletely known, through the *Pedagogical Sketchbook,* in which the language of art is divided into line and structure, dimension and balance, gravitational curve and, finally, kinetic and chromatic energy. His course "Contributions to a theory of pictorial form" is the most extensive presentation yet published. It begins with the point which develops into the line, then the plane and three-dimensionality in space. From these he considers movement, weight, the formation of structure, rhythm, etc. Each of these is analyzed into its components.

Superficially, this appears to be a standard course in the principles of abstract design, which, indeed, it is and could not possibly be other. Klee never wearied of stressing the importance of disciplined technique:

> But what must be stressed even more at this point is that the most exact scientific knowledge of nature, of

plants, animals, the earth and its history, or of the stars, is of no use to us unless we have acquired the necessary equipment for representing it; that the most penetrating understanding of the way these things work together in the universe is useless to us unless we are equipped with the appropriate forms; that the profoundest mind, the most beautiful soul, are of no use to us unless we have the corresponding forms to hand. (p. 100)

But for Klee there was no real distinction between the abstract elements of the artistic language and the human experience in the world. For the elements as he describes them are, in fact, the essence of our experience. If we can lay aside the ancient conviction that our life is made up of rational verbal principle and purpose, of *ideas,* we will quickly realize that our life is really, almost exclusively made up of these, the elements of the formal language, edges, surfaces, mass, weight, open, closed, color, light, dark, in, out, gravity, balance, movement, smooth, rough, hard, soft. This is *all* of our life.

If you doubt the stringency of this statement, I invite you to consider any fundamental human experience. Choose a particularly complex and forceful example—the relation between husband and wife, or more generally, between woman and man.

This is a human experience endlessly talked about, argued about, subjected to philosophers, lawyers, theologians, sociologists, economists, psychologists, biologists, and all the rest of the word-mongers. Yet if we analyzed it step by step, what do we find as its constituent elements?

Most pressingly, perhaps, the dramatic interaction of personalities. But drama is not entirely subject to words; it is the interplay of forces which, to be understood, must be translated into the structured rhythms of the stage—drama and ballet, music or ritual. Much music is not understandable to those who don't know what an orgasm is like. Such a state-

ment is fashionably acceptable. Less satisfactory is the parallel assertion that the orgasm is not understandable by simple experience, by knowing its technique or extolling its virtues. It is to be understood only as its transformation into music is grasped, the developed tension, resolved into wholeness. The orgasm is and must remain an animal act, for we are animals. By music, by architecture, by true liturgy it becomes metaphor, which is the act of becoming human. The orgasm, mediated by music, becomes a human act.

The dramatic action is not simply the interplay of wills but the interplay of forms and obviously there is no interaction of wills outside the interaction of forms. The forms inhabit a context which is space, light, color, heat and cold, odor and all the things that make up the lived world. The forms themselves are appearances—color and shape. They are articulated organisms working according to known mechanical principles. They interact according to identifiable principles of motion, friction and texture, and all the other qualities of the human body.

This is not reductionism. It would be wholly false to Klee as well as to common sense to suggest that so complex a relation should be identified with any of its constituent elements. Rather these are the elements. The relation is understandable only as its elements are understood for any object or relation is understandable only as a continuum from the cell to the ethical principles that are, themselves, part of its structuring.

The word "ethics" must be taken seriously as inseparable from the world of forms.

For Klee, there is no discontinuity between the world of forms and the humanistic world. He speaks, for example, of the "ethical character of movement," meaning a sense of essential movement rather than the appearance of movement. Similarly Ingres spoke of "drawing is the probity of art." The ethical world, which is to say the human world, is not

something belonging to the calculating, argumentative intelligence placed in and above a world of inert forms. Ethics is inherent in the world of forms.

Deeply connected but discernibly different is the world of organic growth. Klee's formal language was built on the principle of growth and movement so the discernible difference here is the awareness of the appearance of nature. This led to his brief but eloquent essay, "Ways of Nature Study."

There are now two directions, or perhaps better, two resonances of nature study. On the one hand, there is the resonance within natural forms of the laws of formal structure. In Klee's words, "True essential form is a synthesis of appearance and figuration" (p. 61).

On the other hand, there is the resonance between external appearance and inner form. Again in Klee's words, "The object grows beyond its appearance through our knowledge of its inner being, through the knowledge that the thing is more than its outward aspect suggests" (p. 66). Lest it appear that Klee is setting up some form of dualism between appearance and reality here is a further statement: "Forms react on us both through their essence and their appearance, those kindred organs of the spirit. The line of demarcation between essence and appearance is faint. There is not clash, just a specific something which demands that the essential be grasped" (p. 154). Essence and appearance as "kindred organs of the spirit." How much philosophical controversy is wiped out by that statement!

Essence, for Klee, is never what it is for those philosophers who contrast essence with existence. Essence is never separable from movement and change. "Thus form may never be regarded as solution, result, end, but should be regarded as genesis, growth, essence. Form as phenomenon is a dangerous chimera" (p. 169).

Thus, in Klee's methodology, Klee's "being-in-the-world,"

we have, so far, these essential elements: the laws of structured form; the laws of forming, of growth; and the appearance of things. A human being is the agent for all these, as we will see in a moment, but so far the human has not been presented as essential to the process.

For Klee, the human element is present, first, as pure fantasy, the purest form of creativity. "Within the will to abstraction," he says, "something appears that has nothing to do with objective reality. Free association supplies a key to the fantasy and formal significance of a picture. Yet this world of illusion is credible. It is situated in the realm of the human" (p. 262).

For one example, take one of the most noted and most popular of Klee's works, the "Twittering Machine" (fig. 31). Presumably, unless you are familiar with Klee, you didn't know what a twittering machine was but now you see the definitive essay on the subject.

The "Twittering Machine" is great fun. It is also extraordinarily lovely. Still more, it injects an element of mystery into experience, strange forms hovering before an immensity of mysterious space. It links into ordinary experience. This may be the only twittering machine in existence but twittering certainly exists. Explicitly he speaks of birds but also of young school girls, or of cocktail parties. But twittering is not simply young girls and birds, it is a quick, light, staccato rhythm.

The machine is also a machine and the painting is a witty commentary on machines. Equally, as in every work by Klee, it explores elements of the making of pictures. No one of these elements supersedes another. It is a cluster of ideas generating a unique work. It would be partly true to say that, if nature were to produce a twittering machine it would look like this, for Klee always works in terms of natural processes. But it is not simply a twittering machine. It is the *picture* of a twittering machine.

This free creative play is essential to Klee's work; its products are the most popular part of his work and deservedly so. But it does not reach the deepest part of what he has done. The conclusive aim of all Klee's work is to find the object that functions as the external equivalent of an essential human mode. The processes of nature have only their simple and repetitive existence except as they center on the human and the human act that places a human being most fruitfully within the created order is the making of the work of art.

Here is Klee's own description of the process. He has described, in his "Ways of Nature Study," the process of analysis, the outward analysis and the inward response. "The sum of such appearance enables the 'I' to draw inferences about the inner object from the optical exterior, and, what is more, intuitive inferences. The optic-physical phenomenon produces feelings which can transform outward impression into functional penetration more or less elaborately, according to their direction. Anatomy becomes physiology" (p. 66). He continues:

> But there are other ways of looking into the object which go still farther, which lead to a humanisation of the object and create, between the "I" and the object, a resonance surpassing all optical foundations. There is the non-optical way of intimate physical contact, earthbound, that reaches the artist from below, and there is the non-optical contact through the cosmic bond that descends from above. It must be emphasized that intensive study leads to experiences which concentrate and simplify the processes of which we have been speaking. For the sake of clarification I might add that the lower way leads through the realm of the static and produces static form, while the upper way leads through the realm of the dynamic. Along the lower way, gravitating toward the center of the earth, lie the problems of static equilibrium that may be characterized by the words: "To stand despite all possibility of falling." We are led to the upper ways by yearning to free ourselves from earthly bonds; by swimming and flying, we free ourselves from constraint in pure mobility.

All ways meet in the eye and there, turned into form,
lead to a synthesis of outward sight and inward visions.
(p. 66)

In simple outline this is Klee's metaphysics and epis-
temology, although it should be evident that in such a pro-
cess, the old terminology makes very little sense.

It remains now to move from these principles to the actual
process of making. Again, we best start with Klee's own de-
scription or descriptive analogy.

What Klee has done is unprecedented in the history of art.
He has sought to go to the roots of creativity, not, as is cus-
tomary, to explain the process or control it, but to place him-
self wholly within it.

His own words again:

> Let me use a parable. The parable of the tree. The
> artist has busied himself with this world of many forms
> and, let us assume, he has in some measure got his
> bearing in it; quietly, all by himself. He is so clearly
> oriented that he orders the flux of phenomena and ex-
> periences. I shall liken this orientation, in the things of
> nature and of life, this complicated order to the roots of
> the tree.
>
> From the roots the sap rises up into the artist, flows
> through him and his eyes. He is the trunk of the tree.
>
> Seized and moved by the force of the current, he
> directs his vision into his work. Visible on all sides, the
> crown of the tree unfolds in space and time. And so
> with the work.
>
> . . . all he does in his appointed place in the tree
> trunk is to gather what rises from the depths and pass it
> on. He neither serves nor commands, but only acts as a
> go-between. His position is humble. He himself is not
> the beauty of the crown; it has merely passed through
> him. (p. 82)

"Humility" is not a word associated with most of the artists
of the Renaissance, who approached the world of art making
as conquering heroes. But Klee's humility before the order-
ing of things ought not to be confused with other attempts

to find a human place in the natural order. Oriental artists, at whichever conditioned extreme, sought to be absorbed into the gentle or the passionate forces of the natural order. Humility became unity which was understood as identity.

Klee made no effort to repudiate his own history or the history of his people and go home to an earlier age, a solution rather desperately sought today. He had absorbed that history, so when he went to nature he went as a natural organism. His purpose was not to be absorbed into nature or nature's general process but to learn the mode of creativity that is appropriate to the distinctively human.

In the hands of a lesser man such a project could have been a sentimental disaster. In the hands of Klee it was a revelation of new and unexplored aspects of being human.

It is of the greatest importance that this did not lead to a subjective or expressionist art as though the natural function and right of a human being is to become like a flower. Instead it led to an extraordinarily "objective" art (the terminology is outdated but I don't know a better). What he seems to have done is undertake an extraordinary penetration of the creative process, not considered simply as a making to the pattern of human use or dominating to the purposes of human conquest but as the bringing to their fulfillment of all forms. This meant that no form should be confused with that which is not of its own nature; it is not of the nature of a human being to be a flower or an animal nor does a juncture of lines come to fruition as a fruit tree does.

Thus the characteristic human function is not to impose human will on the non-human world but to discover its true nature and its most intimate processes and to be the instrument by which they emerge into being.

This is by no means an unconscious process or even a mystical one. It requires a vigorous and precise intellectual discipline and Klee left to us an extraordinary mass of manuscripts.

The writings are the single indispensable guide to his paintings but, finally, it is the paintings that matter. Klee's characteristic procedure was to begin with a small motif, a formal idea, some tiny principle that is ingredient to painting, not to human drama or purpose, not to natural description or resemblance but to painting. Then, as the instrument of the form (or the trunk of the tree), he engendered from that idea its fundamental nature, slowly and carefully nurtured it till it came to completion. At the end, when it was complete or fulfilled, he would see it for what it was and, with his extraordinary poetic sense, see the rhythmic correspondence to some other aspects of human experience and so give it its title. Or, as it was unfolding, he would sense its harmony with something else and begin cautiously to add elements that made apparent the relation.

Now it may be evident why I used the mundane fact that Klee made a remarkable number of works and that a remarkable number of those are fresh and original. For what he has done is to make the originality of the work dependent, not on his own powers of invention but on the reality of things. Klee made of himself the instrument whereby things came into being that had never existed before. He did not conquer but fulfilled his world.

The instrument, the center of Klee's work was the eye, "the thinking eye" as the editor of the English edition of his pedagogical writings translated the German title. But from being the sovereign instrument of the intelligence as it had been in western optics, it became the servant and center.

In the retreat from optics that characterizes the new barbarism, touch has become the new king. The hand exploring the privacies of flesh is the instrument of the intrusive language invading the privacies of soul. The sensual touch dissolves the individual into the mass. The intelligent eye, however, is the fulcrum on which balances the rhythms of the seen world with the rhythms of the felt body. From that bal-

ance there emerges not conquest but harmony. The optics of the truly modern imagination is not the fixing of a static order into a rigid and permanent form but the placing of us into the process of a growing world.

Klee is to be understood only by a careful study of all his works for each is an essential note in a polyphonic harmony. I shall, however, close with an account of one, "Ad marginem." No single work sums up what Klee did but this one contains more of his themes than most.

When this account began we saw the imposition of geometric order on the flux of the natural process. That geometric order had been decisive for art until the end of the nineteenth century. At the same time it has been decisive for religion as well for it was the vertical and horizontal grid that has shaped our cosmology and thus controlled so much of our religion. It is the vertical and horizontal grid that generated the idea of the three-story universe that has been the scaffolding of Christendom's image of the cosmos.

The breakdown of the geometric grid did not begin with Klee or even his cubist predecessors. It began in nineteenth-century architecture even before it did in Einsteinian physics. But we see it in pure form in this painting, "Ad marginem" (fig. 32). There is no clear direction, for the paintings often grow inward from the edges. The world is open in all directions. All is growth, plants, animals, birds; the dark eyes of fantasy beings mingle against a background that is both air and water. In the center a dark red sun glows richly. On each edge a precisely formed letter is inscribed, both containing its everyday meaning, and losing it in the transformation of the letter into a magic symbol. The letter is the logos, reason, but the letter, the word, derives all its strength from the naming of what is.

The geometric grid has been the major instrument in the humanizing of the human. It was an essential instrument in the forming of the soul. Without the discipline of geometry

we could never have found the way out of the involvement with the processes of nature and so we could never have been fully human. The geometric has been both the condition and the instrument for the uncovering of the meaning of the narrative and the resulting discovery of the human soul.

But aged kings became tyrants and the grid took us apart from the processes of our life. There are those who would accept defeat and retreat back into the seductive rhythms of the natural process, abandoning the soul, the ego, so hardly won.

Because it has not understood the process, the church has been able only to protest vainly in the name of argument and morality. Klee can reveal the process to us, show us the method to use.

It was Klee, above all, who discovered that geometry is not apart from process but ingredient to it. It is well, too, to acknowledge that art is not the only resource we have to draw on. Both biologists and physicists have learned that geometry is ingredient to life, order and energy are one.

Thus we have both a new image of the cosmos and a new image of ourselves in it and we even have the elements of a new methodology for the recovery of a faithful humanity.

Klee created an art that has the capacity to restore, replace, us in the world that our own consciousness tore us loose from. He did so by grasping the fundamental instrument of thought as it had not so truly been grasped before. We are human because we can know the metaphor. The burden, the curse, the possibility, the responsibility laid on the human is that no thing or act is simply itself for us; we are not as the birds and the animals are, immediate to the presence of God. We must be aware of them and think about them. What Klee has offered us is the means for that relation, seeing each thing and act for itself, being aware of our self as it is a self, but knowing both most acutely in their

relation. He gives us the means to mediate the fullness of the world to our lonely, aching selves.

We do not repudiate the past I have tried to chronicle in outline. "We do not undertake analyses of works because we want to copy them or because we suspect them. We investigate the methods by which another has created his work in order to set ourselves in motion" (p. 99).

It is now time to draw this journey to an end. But the only journey we can end now is this brief exploration into history and method; the main point of this treatment of Klee, after all, is that he is a guide into the future and not simply an element of the historic past. All I would say now has been present, scattered or implicit, in what has gone before. What should I make explicit at the close? The main rubric of this lecture series had been "Theological Method." What does all this have to do with theological method?

I hope it is clear that I do not treat Klee simply as guide and model, by analogy, to another discipline. Klee is a theologian as I think "theologian" should now be defined; that is, Klee sets out the knowledge of God as it now should be set out, in the only way it can be set out without blasphemy.

Such an assertion raises two questions: Does this suggest the repudiation of the centuries-old discipline of theology? Does this suggest that there is no longer a role for the traditional mode of theology?

Very widely now the answer to both these questions would be "yes." There is much current literature of attack on those forms of the rational intelligence that are considered to have been the source of all our ills. Yet the repudiation of the authority of verbal reason is more apparent than real, more a weapon in an old war than an affirmation of a new world. The repudiation of propositional rationality is carried on in exactly the traditional language, using the same logical forms with the same claim to truth and correspondence to the real. There is the same claim to compulsive authority angrily demanding obedience.

Perhaps not quite the same. Too often we lose the civility that characterizes the humanistic intelligence at its best, the civility toward other people, the civility of the mind that requires an absolute respect for the evidence. Too often now theological argument has become no more than an attempt to use the authority of God as a weapon in the pursuit of some purpose determined by methods wholly apart from that authority. The purpose may, indeed, be good but defended or established by such methods the purpose will be transformed in the image of the method. Christianity is not furthered by rage and violence and one of our gravest dangers is not simply the mindless violence of the mob but the minded violence of the intellectual lusting for power.

Against these contending violences, traditional theologians have sunk into paralyzed helplessness. Many of them no longer have faith in what they are doing, no longer feel any integral connection between their words and the reality of the world. Or they find themselves helpless in the face of an onslaught they cannot understand.

And yet none of this is part of the lesson Klee teaches us and, in defining the work of the artist, he has given a charter for the mode of theology that fits the imaginative structures of our day.

First, he found in the processes of art a definition of the human that can supersede the old dualisms. He returns us to our rooting in nature without any sense that we either could or should be reabsorbed into nature. He redefines the intelligence as an act and function of the whole body.

Second, in redefining the human he sets out our creativity. We are rooted in nature as a tree is rooted in nature. But we are not trees. We "bear fruit" as a tree does in process, but not the fruit of a tree for we are human and not trees and our fruit is human fruit in the human languages.

Third, he redefines our relation to the past and to the tradition. We ought neither to subject ourselves to it nor attempt to escape from it. We learn from the past the modes

and the methods of being human—the methods because they are part of our humanity, the modes of the human because they are part of our response and responsibility. As I have tried to set it out here, we ourselves cannot escape from our ancestors, Egyptian and Greek, Roman and Celt, increasingly now Chinese and African and many others. Nor should we try to escape, for they all have taught us various possibilities of being human.

Fourth, the human personality is inseparable from nature, from history and the abstract laws that inhere in the structure of things. Thus, the realization of the human requires, absolutely, the discipline of quiet and submissive reception of things as they are as well as the active and forceful construction of the new things that pull together what has seemed disparate and disconnected. Satisfaction, self-fulfillment, are products, not purposes. There is no substitute for the hard work of learning the intense reality of things and the language for dealing with things.

Klee was an artist, intensely concerned with vision. Those who work in words necessarily begin with vision for that is one controlling mode of being in the world. But they should never forget that their medium is words and so their discipline is in the order and use of words. So long as they try to live in the assumption that words have final authority over the real, they deceive themselves and the truth is not in them. They belie and betray their ordinary experience.

Their duty is to steep themselves in nature, in the past, in the products of human creativity, in the ordinariness of their own lives, in the action, the passion and the suffering of their own day. Their duty is to train themselves in the order of words and the structures of thought, not as a weapon but as the means whereby the experience of the earth comes through them to flower and fruit. Their duty is to discipline their own souls, in the worshipful service of the structures of the liturgy, in the passionate service of the body in the love

of wife or husband, in the loving nurture of persons in the care of children and the building of a family, in the sustaining of the social order and the service of those in need, in passionate regret for the failure and corruption of our own purpose.

Theology is not done in words only. It is done in all of the human languages and its unavoidable instrument is the whole human flesh. Its starting point is the same for all, the feeling and passionate flesh engaged with the fullness of the earth. The fruit differs, as apples differ from pears, as books differ from paintings. They are all modes of the human if we make them so.

Klee himself should speak last, with only the reminder that the final word begins with a capital letter.

> His growth in the vision and contemplation of nature enables him to rise towards a metaphysical view of the world and to form free abstract structures which surpass schematic intention and achieve a new naturalness, the naturalness of the work. Then he creates a work, or participates in the creation of works, that are the image of God's work. (67)

> Man is not finished. One must be ready to develop, open to change; and in one's life an exalted child, a child of creation, of the Creator. (p. 42)

NOTES

Chapter Two

1. Stephen Crites, "The Narrative Quality of Experience," *Journal of the American Academy of Religion* XXXIX, No. 3 (September 1971): 29.
2. Rhys Carpenter, *The Esthetic Basis of Greek Art* (Bloomington: Indiana University Press, 1959), p. 11.
3. Philip Fehl, *The Classical Monument* (New York: New York University Press, 1972), pp. 28–29.
4. Guido von Kaschnitz, *Kleine Schriften zur Struktur; Ansgewählte Schriften,* Band I (Berlin: Gebrüder Mann Verlag, 1965), *passim.*

Chapter Three

1. Theocritus, *Eleventh Idyll,* in *Greek Pastoral Poetry,* trans. by Anthony Holden (Harmondsworth: Penguin Books, 1947), pp. 88–90.
2. Peter von Blanckenhagen and Christine Alexander, "The Paintings from Boscotrecase," *Mitteilungen des Deutsches Archaeologischen Institut,* 1958.
3. Ibid., p. 41.
4. Ibid., p. 35.
5. Ibid., pp. 54–55.
6. Sheldon Nodelman, "How to Read a Roman Portrait," *Art in America* (January-February 1975): 30–31.
7. Ibid., p. 27.

Chapter Four

1. Andre Grabar and Carl Nordenfalk, *Early Medieval Painting,* trans. by Stuart Gilbert (Albert Skira, 1957).

Chapter Six

1. Ian Nairn, *Nairn's London* (Harmondsworth: Penguin Books, 1966), p. 168.

Chapter Seven

1. William Ivins, *Prints and Visual Communication* (Cambridge, Mass.: M.I.T. Press, 1953), pp. 15, 91, and *passim.*
2. Lynn White, Jr., "Technology and Invention in the Middle Ages," *Speculum* XV (April 1940).
3. Stephen Toulmin and June Goodfield, *The Architecture of Matter* (New York: Harper & Row, 1966), p. 375.
4. Ibid., p. 377.
5. This and all the following quotations are from vol. I of *The Thinking Eye: Paul Klee Notebooks,* ed. by Jurg Spiller, trans. by Ralph Mannheim (New York: George Wittenborn, Inc., 1960; London: Percy Lund, Humphries & Co., Ltd., 1961), and used by permission of Wittenborn Art Books, Inc. Numbers in parenthesis refer to pages in that edition.

INDEX